MONUMENTAL DRAWING
WORKS BY 22 CONTEMPORARY AMERICANS

MONUMENTAL DRAWING
WORKS BY 22 CONTEMPORARY AMERICANS

ZIGI BEN-HAIM
CYNTHIA CARLSON
ROBERT CUMMING
CARROLL DUNHAM
JOYCE FILLIP
JOHN HIMMELFARB
BRYAN HUNT
ROBERT LONGO
ROBERT MOSKOWITZ
BRUCE NAUMAN
JOHN NEWMAN
DIANE OLIVIER
ELFI SCHUSELKA
RICHARD SERRA
ROBERT STACKHOUSE
DONALD SULTAN
ANDREW TOPOLSKI
MICHAEL TRACY
RANDY L. TWADDLE
ROBIN WINTERS
TERRY WINTERS
MICHAEL ZWACK

THE BROOKLYN MUSEUM
SEPTEMBER 19–NOVEMBER 10, 1986

Published for the exhibition
Monumental Drawing:
Works by 22 Contemporary Americans

The Brooklyn Museum
September 19–November 10, 1986

This exhibition was made possible, in part, by a grant from the National Endowment for the Arts, a federal agency, and the New York State Council on the Arts.

Cover:
Robert Moskowitz
Thinker, 1982
Pastel on paper, 53 x 31¼ inches
Collection of the artist

Photograph Credits

Jon Abbott: 25, 53
Ken Brown: 31
D. James Dee: 13, 37
Joyce Fillip: 21
Robert Haavie: 35
Ruyell Ho: 23
Robert E. Mates: 39
Andrew Moore: cover, 29
Peter Muscato: 41, 45, 51
Pelka/Noble: 15, 19, 27, 33, 55
Bill Steffy: 49
Jerry L. Thompson: 43
Robert Ziebell: 47

Library of Congress Cataloging-in-Publication Data

Kotik, Charlotta, 1940–
 Monumental drawing.

 Published for the exhibition at the Brooklyn
Museum, Sept. 19–Nov. 10, 1986.
 Bibliography: p.
 1. Drawing, American—United States—Exhibitions. 2. Drawing—
20th century—United States—Exhibitions.
I. Brooklyn Museum. II. Title.
NC108.K6 1986 741.973'074'014723 86-19328
ISBN 0-87273-106-5

Designed and published by The Brooklyn Museum, 200 Eastern Parkway, Brooklyn, New York 11238.
Typeset in Triumvirate Condensed and printed in the U.S.A. by Albert H. Vela Co. Inc., New York City.
Designed by Richard Waller. Edited by Elaine Koss.

FOREWORD

The Brooklyn Museum has a longstanding commitment to the collection and exhibition of works on paper. Its Department of Prints and Drawings has an outstanding permanent collection and has been organizing the Museum's National Print Exhibition, the major ongoing print survey in America, since 1947.

Therefore, it was a logical step when in 1980 the Museum inaugurated a series of exhibitions devoted to contemporary drawings. The first installment in the series, *American Drawing in Black and White: 1970–1980,* was curated by the late Gene Baro, then Consulting Curator of Prints and Drawings. The present exhibition, the second in the series, was organized by Charlotta Kotik, who served as Curator of Prints and Drawings between 1983 and 1985 and continued in charge of the project after her transfer to the Department of Painting and Sculpture as Curator of Contemporary Art.

Monumental Drawing: Works by 22 Contemporary Americans offers a unique opportunity to study some prominent examples of current drawing and to examine the growing importance of this medium in the art world.

ROBERT T. BUCK
Director
The Brooklyn Museum

ACKNOWLEDGMENTS

The cooperation of many people is needed for the successful realization of any exhibition, large or small. In the organization of this exhibition, which evolved over an extended period of time, I was fortunate to enjoy such cooperation. Indeed, the list of colleagues from whom I received support is much too long for printing. As much as I appreciated their help, I am limited here to acknowledging a few people who provided special assistance.

The Museum's Director, Robert T. Buck, was supportive of the project from its inception, as was Roy Eddey, the Deputy Director. Laural Weintraub, Museum Intern through the University of Southern California in Los Angeles, aided by the earlier research of Museum Intern Shelly Leizman, not only compiled all the artists' bibliographies and exhibition histories but also wrote the paragraphs on Joyce Fillip and Randy L. Twaddle and organized all loans and administrative tasks in conjunction with Registrar Elizabeth Reynolds. Assistant Conservator Antoinette Owen and Conservation Assistant Peter Muscato aided with the difficult installation. Without Managing Editor Elaine Koss and Chief Designer Richard Waller this publication would never have been completed. For their hard work and good humor I extend my profound thanks. I would also like to thank Terri O'Hara, Assistant in the Department of Painting and Sculpture, who skillfully typed the manuscript. I am grateful to Bernice Rose, Curator in the Department of Drawings at The Museum of Modern Art, for giving freely of her time in discussing the exhibition and facilitating some of the essential loans. Likewise, I am thankful to the collectors who were willing to part with their works and to the numerous galleries that lent pieces to the exhibition. I especially wish to acknowledge Simon Watson of Baskerville + Watson, New York; Peter Freeman of Blum Helman Gallery, New York; Pat Marie Caporaso of Castelli Uptown, New York; Susan Brundage and Mary Jo Marks of Leo Castelli Gallery, New

York; Beth Urdang of Jeffrey Hoffeld & Co., New York; Michael Klein of Michael Klein Inc., New York; Ann Philbin of Curt Marcus Gallery, New York; Helene Winer of Metro Pictures, New York; Stefano Basilico of Sonnabend Gallery, New York; Hiram Butler and David Miller of Butler Gallery, Houston; Betty Moody of Moody Gallery, Houston; and Michael Fitzsimmons of Struve Gallery, Chicago. The cooperation of these individuals and the assistance of their staffs in locating works of art and formalizing loan agreements were absolutely essential. Last but not least I want to thank the artists whose works are included in the exhibition, for their work, their ideas, and their time spent in discussion of this project.

CHARLOTTA KOTIK
Curator of Contemporary Art
The Brooklyn Museum

INTRODUCTION

Monumental Drawing: Works by 22 Contemporary Americans is the second in a series of national drawing exhibitions organized by The Brooklyn Museum. The first in the series, the 1980 exhibition *American Drawing in Black and White: 1970–1980,* featured a wide spectrum of works in a variety of techniques and subject matter. This exhibition also brings together a diverse group of works by both well-established and up-and-coming artists from across the country, revealing a multiplicity of expressions and styles that reflects the pluralism of the current American art scene. Yet despite this multiplicity, *Monumental Drawing* is more narrowly focused than the 1980 exhibition, for it attempts to investigate how the increasing popularity of drawing has influenced the physical and intellectual scale of recent works on paper and to inquire into the profound changes that have affected this oldest of media within the past few decades.

Since World War II, drawing has undergone changes even more dramatic than those affecting painting and sculpture, progressing from a medium used primarily for preliminary sketches for works in other materials toward a medium employed for independent, fully realized works that freely integrate properties historically associated with painting and sculpture. Essentially, the category of drawing has expanded so profoundly that the old classifications and divisions have become obsolete.

Although this is a fairly recent development, it has its roots in the last century. With the formulation of the nineteenth-century idea of the artist-hero isolated by virtue of his genius from the rest of humanity came an emphasis on individuality and spontaneity and their importance to the artist's oeuvre. Viewers became more receptive to a sketchy or unfinished look in the works of artists who were heirs to a pure linear tradition. In general, the new appreciation of spontaneity and immediacy brought about a natural reevaluation of drawing as the most suitable

means for the capture of fleeting impressions or the externalization of internal feelings.

Most art movements in the United States during the past forty years or so have reflected a process whereby the concept of the artwork developed during the execution of the piece itself. This tendency was most clearly formulated in the work of the Abstract Expressionists. For artists such as Jackson Pollock, Willem de Kooning, and Franz Kline, the division between drawing and painting became especially narrow as the linear and painterly qualities in their works merged. This narrowing of the gap between the two media stemmed in part from the artists' investigation of the principles of automatism outlined by the Surrealists, who believed that the hand is a conduit of the subconscious and that the mark it leaves is a permanent record of the process of creation itself. With such ideas in vogue, the receptive paper sheet quickly gained its place as a support for finished independent works.

The 1960s and 1970s were decades of intense search—for new aesthetics, new systems, a new philosophy of the creative act. In this atmosphere of developing and changing ideas, where old ones were inevitably questioned and new ones proclaimed (and sometimes abandoned) in swift succession, drawing served the most diverse intentions of artists. During the mid- and late sixties the emergence of site-specific works—installations, environments, and earthworks—generated an enormously important category of works on paper. These were sometimes the only documents of temporary installations and were often the only visualization of concepts that were never realized. The notion of unfinished work, where process is discernible and in fact can be abandoned and recovered; the notion of impermanence and freedom frequently associated with works on paper; the notion of such works being lesser commodities in the art market—all these made drawing appealing to the spirit of the

time. Drawing flourished, and what were once intimate objects intended for private perusal grew into frequently colossal public statements. While still retaining the qualities accorded it in the past, the medium incorporated numerous new physical and conceptual properties. Its importance became undeniable, and it was assigned more prominence by galleries, museums, collectors, and critics.

However, much work remains to be done to ensure a full appreciation of the various aspects of this singular medium. *Monumental Drawing* is an attempt to move in that direction. For the artists represented here, works on paper, while sometimes functioning as a bridge to those in other media, are finished independent pieces with their own sets of rules. Although all the works in the exhibition use large scale as one of their essential properties, their monumentality is not defined by scale alone. Rather, it is the integrity of their ideas, together with their physical scale, that makes these works truly monumental.

Large drawings evolve over an extended period of time. They cannot, for purely physical reasons, be executed quickly and therefore require a more concentrated effort to sustain the original concept. Within this passage of time, ideas germinate in a state of constant transformation. Only the strong and consistent idea can survive the lengthy process of its own materialization, which is also a process of constant questioning, and result in a truly meaningful statement. Large scale is not a virtue in itself—an 11-by-8-inch drawing can be as powerful as a drawing on a giant sheet—but while in the density of small scale unresolved problems can sometimes go undetected, they immediately become apparent when exposed in the vastness of large pictorial space. Independent large drawings are totally revealing of the intentions and capabilities of the artist: the good and the bad both get magnified.

There are more expressions and styles in drawing today than those

represented in this exhibition. One important category that has evolved since 1960—wall drawing—is among those omitted. Spatial as well as economic limitations precluded its representation in the necessary depth. At any rate, *Monumental Drawing* is not intended to summarize the aesthetic possibilities of drawing, which are, after all, as limitless as the imagination of the artists themselves. Rather, it presents a selection of works on paper, the most traditional support in the graphic arts, by artists whose inquiry into the possibilities of large-scale drawing have brought a deeper understanding of this versatile and noble medium.

CHARLOTTA KOTIK

ZIGI BEN-HAIM

Born 1945 in Baghdad, Iraq

Studied 1966–70 at the Auni Institute of Fine Arts, Tel Aviv; studied 1971 at the California College of Arts and Crafts, Oakland; M.F.A. 1974, California State University, San Francisco

Resides in New York

Zigi Ben-Haim's recent large drawings are a logical outcome of his complex and prolific career. In their structure they relate to the compositional schemes of the low reliefs he has exhibited in the past few years, which are created by applying twigs, paper, and various pigments to unevenly shaped surfaces.

The prominent feature of Ben-Haim's new drawing series is an evocation of deep space inhabited mainly by triangular forms floating in what seems to be a state of permanent flux. These works suggest the process of creation itself, implying that movement and the attraction of opposites are in fact unifying forces.

Paper has always been an important material for Ben-Haim. To him, it is at once a repository of world cultural tradition and a common bond among many nations all around the globe. He likes it for its pliability, which makes it useful for sculptural work, and for its ability to endow color with a luminosity no other support can give.

Presently Ben-Haim is using the color of oxidized copper which in Iraq, where he was born and lived through his early childhood, marked the houses of the poor. Because this color is associated in our culture with the majestic cupolas of churches and banks, contrasting connotations often emanate from his works.

Selected Individual Exhibitions

1976
Bertha Urdang Gallery, New York. Catalogue

1978
Munro-Gallerie, Hamburg, West Germany

1980
Galerie Annemarie de Kruijff, Paris

1981
Gallery Gimel, Jerusalem

1982
Art Gallery of Hamilton, Ontario. Catalogue, with text by William Zimmer

1984
The Israel Museum, Jerusalem. Catalogue, with text by Yigal Zalmona

1985
Baumgartner Gallery, Washington, D.C.

1986
P.S. 1, The Institute for Art and Urban Resources, Long Island City, New York

Selected Group Exhibitions

1978
Dayton Art Institute, Ohio, *Paper*. Catalogue

1979
Art Gallery of Ontario, Toronto

Galerie Loyse Oppenheim, Nyon, Switzerland

1980
Albright-Knox Art Gallery, Buffalo, *With Paper, About Paper*. Catalogue, with text by Charlotta Kotik

1982
The Oakland Museum, California, *International Sculpture Conference*

1983
Turman Gallery, Indiana State University, Terre Haute, *Paper Transformed*. Catalogue, with text by Bert Brouwer

1985
University of Hawaii at Manoa Art Gallery, Honolulu, *Second International Shoebox Sculpture Exhibition*. Traveled. Catalogue

Jamie Szoke Gallery, New York, *Public Art in the Eighties*

Selected Bibliography

1975
Noel Frackman. "Jack Lembeck/Amnon Ben-Haim: Louis K. Meisel." *Arts Magazine*, vol. 49, no. 9 (May 1975), pp. 9–10.

1977
Pat Mainardi. "A. Ben-Haim: Bertha Urdang." *Arts Magazine*, vol. 51, no. 6 (February 1977), p. 30.

1983
Judd Tully. "Paper Chase." *Portfolio Magazine*, vol. 5, no. 3 (May–June 1983), pp. 78–85.

1984
Vivien Raynor. "Works Made of Paper Not on It." *The New York Times*, April 22, 1984, section XXIII, p. 18.

1985
Michael Brenson. "Environmental Works." *The New York Times*, March 1, 1985, section III, p. 25.

Joan Marter. "Contradictory Worlds: The Art of Zigi Ben-Haim." *Arts Magazine*, vol. 60, no. 3 (November 1985), pp. 102–3.

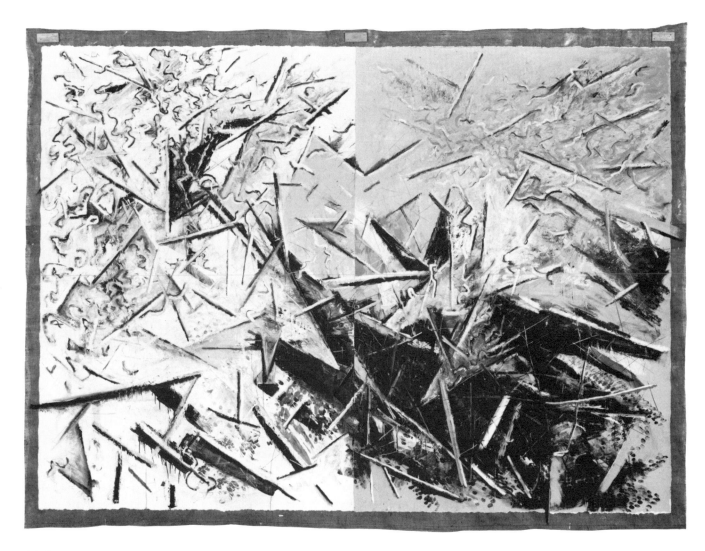

ZIGI BEN-HAIM
Floating Scape #1, 1985
Oil pastel, synthetic charcoal, and pigments on
 primed paper and burlap, 88 x 119 inches
Collection of the artist

CYNTHIA CARLSON

Born 1942 in Chicago

B.F.A. 1965, School of The Art Institute of Chicago; M.F.A. 1967, Pratt Institute, Brooklyn

Resides in New York

The drawings by Cynthia Carlson included in this exhibition may seem like something of a deviation from the decorative site-specific works she has been creating for well over a decade in various alternative spaces, galleries, and museums. But they relate to a reevaluation of her installation work that she undertook in 1984, around the time she was asked to do a project at Buffalo's Albright-Knox Art Gallery. While visiting Buffalo in preparation for the project, she was struck by the beauty and peculiarity of the monuments in the city's Forest Lawn Cemetery. Her plans took a surprising turn, resulting in an installation at once portable and site-specific. Carlson filled the space with large-scale renderings of the monuments executed in charcoal and pastel and frequently adorned with copper or silver leaf. Many of these drawings were mounted on painted wooden frames, becoming three-dimensional objects that referred back to their massive stone antecedents.

Selected Individual Exhibitions

1975
Hundred Acres Gallery, New York

1977
Marianne Deson Gallery, Chicago

1979
Barbara Toll Fine Arts, New York

The Pennsylvania Academy of the Fine Arts, Philadelphia

1980
Allen Memorial Art Museum, Oberlin College, Ohio. Catalogue, with text by William Olander

1981
The Hudson River Museum of Westchester, Yonkers, New York

1982
Milwaukee Art Museum. Brochure, with text by Russell Bowman

1983
Pratt Institute, Brooklyn

1985
Albright-Knox Art Gallery and HALLWALLS, Buffalo. Brochure, with text by Cheryl A. Brutvan

Selected Group Exhibitions

1973
Whitney Museum of American Art, New York, *1973 Biennial Exhibition.* Catalogue

Whitney Museum of American Art, New York, *Extraordinary Realities.* Traveled. Catalogue, with text by Robert Doty

1977
P.S. 1, The Institute for Art and Urban Resources, Long Island City, New York, *Pattern Painting*

1978
Renaissance Society at the University of Chicago, *Thick Paint.* Catalogue

1979
Institute of Contemporary Art, University of Pennsylvania, Philadelphia, *The Decorative Impulse.* Traveled. Catalogue, with text by Janet Kardon

1981
Hayden Gallery, Massachusetts Institute of Technology, Cambridge, *Rooms.* Catalogue

1983
The Hudson River Museum of Westchester, Yonkers, New York, *Ornamentalism: The New Decorativeness in Architecture and Design.* Catalogue

1984
The Queens Museum, Flushing, New York, *Activated Walls.* Catalogue, with text by Ileen Sheppard

1985
Brooklyn Bridge Anchorage, Brooklyn, *Art at the Anchorage*

Palladium, New York, *Guerrilla Girls*

Bernice Steinbaum Gallery, New York, *Adornments*

1986
Vanguard Gallery, Philadelphia

Selected Bibliography

1975
Barbara Zucker. "Cynthia Carlson: Hundred Acres." *Art News,* vol. 74, no. 5 (May 1975), pp. 96–97.

1976
Carter Ratcliff. "The Paint Thickens." *Artforum,* vol. 14, no. 10 (Summer 1976), pp. 43–47.

Jay Gorney. "Cynthia Carlson." *Arts Magazine,* vol. 51, no. 2 (October 1976), p. 13.

1978
Edit deAk. "Cynthia Carlson: C.U.N.Y. Graduate Center Mall." *Artforum,* vol. 16, no. 7 (March 1978), p. 68.

1979
Jeanne Silverthorne. "Now You See It, Now You Don't: The Ambiguous Relief, Part I: Cynthia Carlson." *Arts Exchange* (Philadelphia), June 1979, pp. 16–22.

1980
April Kingsley. "Cynthia Carlson: The Subversive Intent of the Decorative Impulse." *Arts Magazine,* vol. 54, no. 7 (March 1980), pp. 90–91.

1983
Eleanor Heartney. "Cynthia Carlson." *Arts Magazine,* vol. 57, no. 10 (June 1983), p. 11.

1984
Corinne Robins. *The Pluralist Era: American Art, 1968–1982.* New York: Harper & Row.

John Russell. "The Decorative Tradition." *The New York Times,* April 20, 1984, p. C21.

1986
Reagan Upshaw. "Cynthia Carlson: Memento Mori." *Art in America,* vol. 74, no. 7 (July 1986), pp. 108–11.

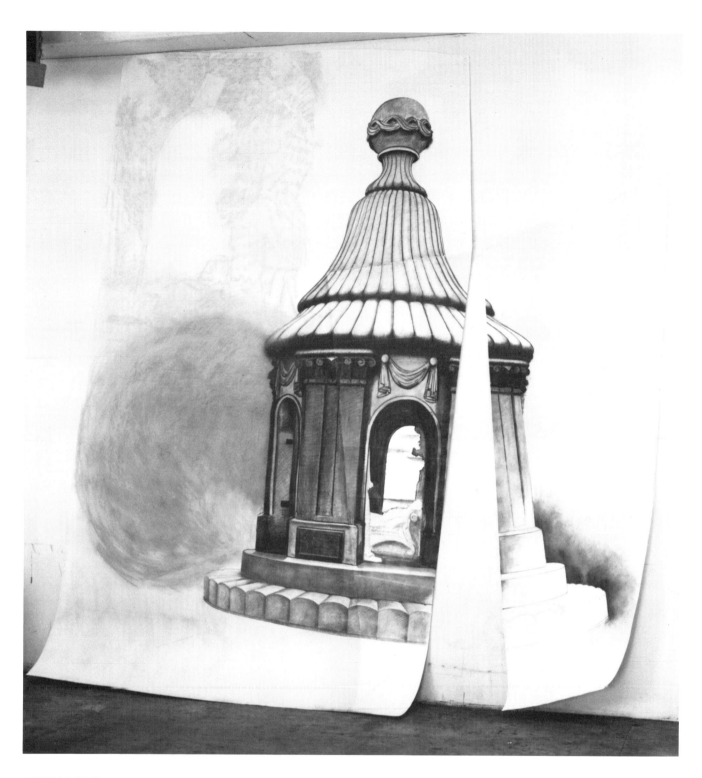

CYNTHIA CARLSON
Blocher, 1985
Charcoal, pastel, and copper leaf on paper with
 collage, 2 sections, 138 x 132 inches overall
Collection of the artist

ROBERT CUMMING

Born 1943 in Worcester, Massachusetts

B.F.A. 1965, Massachusetts College of Art, Boston; M.F.A. 1967, University of Illinois, Champaign-Urbana

Resides in West Suffield, Connecticut

Although Robert Cumming is known primarily for his photographic work, he has long had a predilection for using various other media. Drawing as an independent activity is relatively new for him, constituting yet another means for investigating the physical universe and its frequently ironic relationships. Rendered in a beautifully realistic style, but loose enough not to obscure a degree of magic, Cumming's objects are seemingly familiar. And they partially are: a combination of the real and imaginary is ever present. The stylized lettering on the borders of much of his recent work alludes to his interest in writing, linguistics, and typography.

Selected Individual Exhibitions

1976
Los Angeles Institute of Contemporary Art

University of Iowa Museum of Art, Iowa City

1978
University of Rhode Island Gallery, Kingston

Real Art Ways, Hartford, Connecticut

1979
Institute of Modern Art, Brisbane, Australia. Traveled

1980
Edith C. Blum Art Institute, Bard College, Annandale-on-Hudson, New York

Rhode Island School of Design, Providence

1981
The Art Institute of Chicago

1982
Castelli Graphics, New York

1984
Van Straaten Gallery, Chicago

1985
Castelli Graphics, New York

Carpenter + Hochman, Dallas

1986
San Francisco Museum of Modern Art

Whitney Museum of American Art, New York

Selected Group Exhibitions

1976
The Israel Museum, Jerusalem, *The Artist and the Photograph*. Catalogue

1977
Musée d'Art Moderne de la Ville de Paris, *Biennale de Paris*. Catalogue

Whitney Museum of American Art, New York, *1977 Biennial Exhibition*. Catalogue

Contemporary Arts Museum, Houston, *American Narrative/Story Art: 1967–1977*. Traveled. Catalogue, with text by Alan Sondheim and Marc Freidus

1978
The Museum of Modern Art, New York, *Mirrors and Windows: American Photography Since 1960*. Traveled. Catalogue, with text by John Szarkowski

1980
Kunsthaus Zürich, Zurich, *Farbwerke*. Traveled. Catalogue

International Museum of Photography at George Eastman House, Rochester, New York, *The Photographer's Hand*. Traveled. Catalogue

1982
The Corcoran Gallery of Art, Washington, D.C., *Color as Form: A History of Color Photography*. Traveled. Catalogue

Rotterdam Kunststichting, Netherlands, *Staged Photo Events*. Traveled. Catalogue

1983
The New Museum of Contemporary Art, New York, *Language, Drama, Source and Vision*

Selected Bibliography

1975
P. G. Foschi. "Robert Cumming's Eccentric Illusions." *Artforum*, vol. 13, no. 10 (Summer 1975), pp. 38–39.

1977
James Hugunin. "Robert Cumming's Endless Quantification." *Artweek* (Oakland, California), vol. 8, no. 32 (October 1, 1977), p. 15.

1978
Ronald J. Onorato. [R. Cumming, University of Rhode Island, reviewed.] *Artforum*, vol. 16, no. 8 (April 1978), pp. 73–74.

James Hugunin. "Robert Cumming: 'Trucage,' Falsehoods." *Afterimage* (Rochester, New York), vol. 6, no. 5 (December 1978), pp. 8–9.

1979
Melinda Wortz. "Crawling, Like Alice, Down the Rabbit Hole." *Art News*, vol. 78, no. 1 (January 1979), p. 71.

1982
Andy Grundberg. "A Purposeful Blurring of Illusion and Reality." *The New York Times*, May 30, 1982, section 2, p. 27.

L. Zelevansky. [R. Cumming, Castelli Graphics, reviewed.] *Art News*, vol. 81, no. 9 (November 1982), p. 197.

1983
C. Hagen. "Robert Cumming's Subject-Object." *Artforum*, vol. 21, no. 10 (Summer 1983), pp. 36–41.

1985
Abbe Don. "Fragmented Narratives." *Artweek*, vol. 16, no. 17 (April 27, 1985), p. 4.

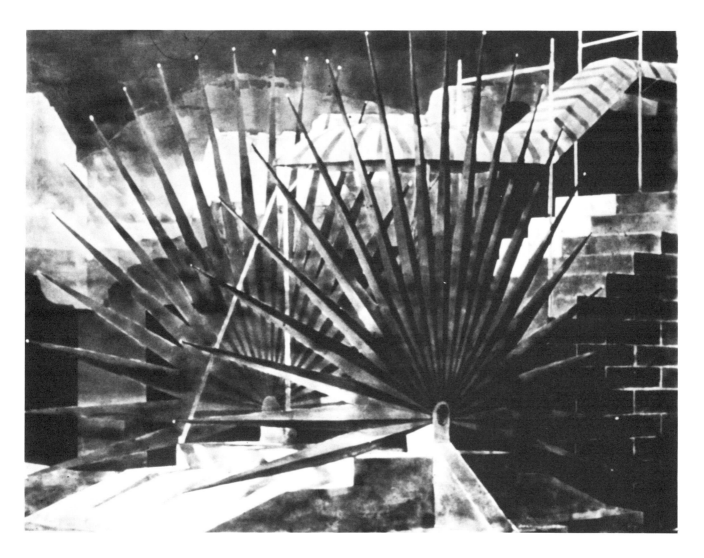

ROBERT CUMMING
Special Entry, 1986
Acrylic on paper, 60 x 77 inches
Castelli Uptown, New York

CARROLL DUNHAM

Born 1949 in New Haven, Connecticut

B.A. 1972, Trinity College, Hartford, Connecticut

Resides in New York

Carroll Dunham's work has decidedly graphic qualities: linear elements structure space, outline shapes, and carry the viewer into an illusion of depth. Drawing is an essential medium for Dunham, and he values it as equal to painting; both media are so thoroughly integrated in his work that it is not easy to determine where drawing stops and painting begins. Although his work pays homage to Surrealism, and his fantastic biomorphic shapes align him in spirit with Terry Winters, Dunham is a profoundly independent artist. He systematically poses and solves problems for himself, as in the group *Seventeen Drawings,* which revolves around a set of given procedures, materials, and sizes, of which *M* and *P* are part. In 1980 Dunham started to use wood veneer as a support for his work. The material naturally influences the appearance of his colors and sometimes, albeit infrequently, affects the composition, as when he traces the inherent design of the wood grain.

Selected Individual Exhibitions

1981
Artists Space, New York

1985
Daniel Weinberg Gallery, Los Angeles

1986
Baskerville + Watson Gallery, New York

Selected Group Exhibitions

1978
The Drawing Center, New York, *Line-Up.* Traveled

1979
The Baltimore Museum of Art, *Selector's Choice*

1981
Hayden Gallery, Massachusetts Institute of Technology, Cambridge, *Four Painters.* Catalogue, with text by Kathy Halbreich

1983
Hamilton Gallery, New York, *New Biomorphism and Automatism*

HALLWALLS, Buffalo, *Nine Painters.* Catalogue, with text by Claudia Gould

1985
Baxter Art Gallery, California Institute of Technology, Pasadena, and The Parrish Art Museum, Southampton, New York, *Painting as Landscape*

1986
Jeffrey Hoffeld & Co., New York, *Drawings: Carroll Dunham, John Newman & Terry Winters*

Selected Bibliography

1983
Klaus Kertess. "Carroll Dunham: Painting Against the Grain—Painting with the Grain." *Artforum,* vol. 21, no. 10 (June 1983), pp. 53-54.

1984
Glenn O'Brien. "Psychedelic Art: Flashing Back." *Artforum,* vol. 22, no. 7 (March 1984), pp. 73-79.

Dan Cameron. "Neo-Surrealism: Having It Both Ways." *Arts Magazine,* vol. 59, no. 3 (November 1984), pp. 68-72.

1985
Brooks Adams. "Carroll Dunham at Baskerville + Watson." *Art in America,* vol. 73, no. 10 (October 1985), pp. 152-53.

1986
Robert Mahoney. "John Newman/Carroll Dunham." *Arts Magazine,* vol. 60, no. 10 (Summer 1986), p. 127.

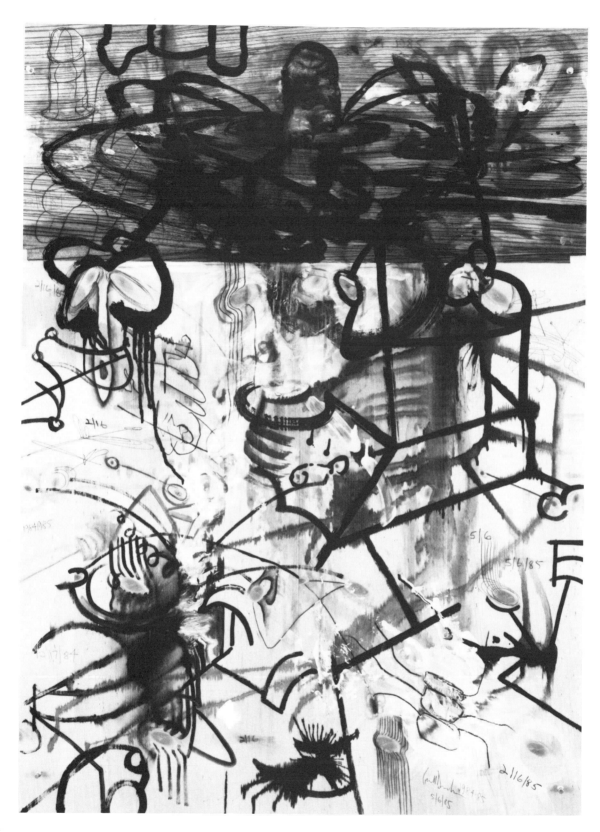

CARROLL DUNHAM
Untitled 5/6/85, 1985
Casein, flashe, casein emulsion, carbon pencil,
 charcoal, ink, and linen on zebrano and
 knotty pine, 42¾ x 31¼ inches
The Museum of Modern Art, New York; The
 Louis and Bessie Adler Fund

JOYCE FILLIP

Born 1953 in Chicago

B.F.A. 1975, University of Illinois, Champaign-Urbana; M.F.A. 1978, University of California, Davis

Resides in Philadelphia

The sheer size of Joyce Fillip's charcoal and pastel drawings of natural disasters endows them with the monumental impact of natural forces unleashed. Her sensibility differs somewhat from that of many of the other artists seen in this exhibition: she is not in the least concerned with formal abstraction; rather, her images have a literalness and naïveté that render her subjects preciously familiar, like the visions of childhood inspired by the awesome events of fairy tales. There is perhaps too a level of allegory here, for the apocalyptic upheavals she portrays may be read as warnings of some sort of imminent violence. Regardless of what we are able to read into Fillip's *Natural Disasters* (for these images are essentially hermetic), the artist combines large-scale, dynamic mark making and forceful subject matter to create a truly monumental effect.

Selected Individual Exhibitions

1981
Samuel S. Fleisher Art Memorial, Philadelphia Museum of Art

1982
Florence Wilcox Gallery, Swarthmore College, Pennsylvania

Selected Group Exhibitions

1978
E. B. Crocker Art Gallery, Sacramento, California, *Crocker-Kingsley Art Annual 1978*

1980
Cheltenham Art Centre, Pennsylvania, *Primavera*

1981
Alternative Museum, New York, *Emerging Artists*

1984
Marian Locks Gallery, Philadelphia, *Two Artists*

Painted Bride Art Center, Philadelphia, *Sculpture Show*

The Drawing Center, New York

1985
Frumkin and Struve Gallery, Chicago, *Works on Paper*

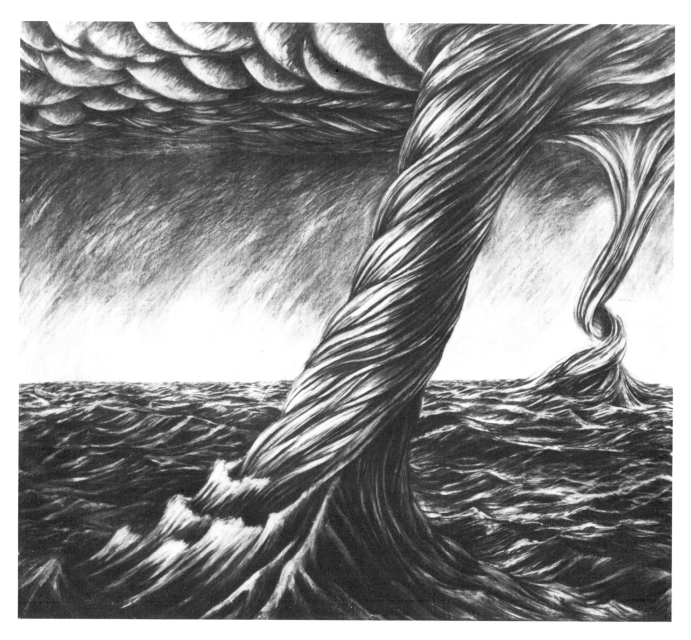

JOYCE FILLIP
Waterspouts, from the series *Natural Disasters*, 1983
Charcoal and pastel on paper, 96 x 108 inches
Struve Gallery, Chicago

JOHN HIMMELFARB

Born 1946 in Chicago

B.A. 1968, Harvard College, Cambridge, Massachusetts

Resides in Oak Park, Illinois

John Himmelfarb spent his youth in the forests of Illinois, where his parents, both artists, built a house shortly after World War II. While passing innumerable hours playing and "living" in the woods, he began to anthropomorphize the animals and trees, filling the woods with spirits and creating his own tales and epics. This background is clearly discernible in the majority of his drawings. His dense compositions, executed primarily in brush and ink, are enlivened by a semblance of constant movement created by creatures populating the growth. Mystery pervades his work, but rather than threatening, it is often humorous, frequently commenting on human conditions in fablelike parables.

Selected Individual Exhibitions

1978
Sheldon Memorial Art Gallery, University of Nebraska, Lincoln

1979
Merwin Gallery, Illinois Wesleyan University, Bloomington, Illinois

Terry Dintenfass, New York

1980
Hull Gallery, Washington, D.C.

1982
Barbara Balkin Gallery, Chicago

1985
Area X Gallery, New York

Sioux City Art Center, Iowa

1986
Davenport Art Gallery, Sioux City, Iowa. Catalogue, with text by L. G. Hoffman and Frederick Ted Castle

Terry Dintenfass, New York

Selected Group Exhibitions

1974
The Brooklyn Museum, *Nineteenth National Print Exhibition.* Traveled. Catalogue

1977
Oklahoma Art Center, Oklahoma City, *19th Annual Exhibition of Prints & Drawings*

1978
The Art Institute of Chicago, *Artists of Chicago and Vicinity: Works on Paper.* Catalogue

1980
The Brooklyn Museum, *American Drawing in Black and White: 1970-1980.* Catalogue

1981
Museum of Contemporary Art, Chicago, *Artists' Books*

1983
Des Moines Art Center, Iowa, *Director's Choice*

American Academy and Institute of Arts and Letters, New York, *Hassam and Speicher Fund Purchase Exhibition*

1985
The Art Institute of Chicago, *81st Exhibition by Artists of Chicago and Vicinity.* Catalogue

Harcus Gallery, Boston, *Jungle Fever*

1986
Area X Gallery, New York, *Faces*

Selected Bibliography

1985
Matthew Rose. "An Interview with John Himmelfarb." *Arts Magazine,* vol. 60, no. 2 (October 1985), pp. 68-72.

Alice Thorson. "Chicago and Vicinity Show/1985." *New Art Examiner* (Chicago), vol. 13, no. 2 (October 1985), pp. 32-34.

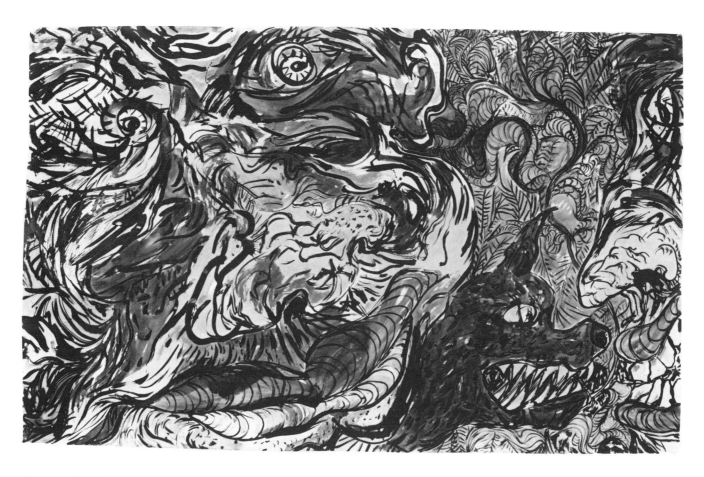

JOHN HIMMELFARB
Giants Meeting, 1986
Ink on paper, 96 x 144 inches
Terry Dintenfass, New York

BRYAN HUNT

Born 1947 in Terre Haute, Indiana

B.F.A. 1971, Otis Art Institute, Los Angeles

Participated 1972 in Independent Study Program, Whitney Museum of American Art, New York

Resides in New York

Bryan Hunt is a sculptor for whom drawing is a vital activity. Frequently finding himself physically removed from his pieces because of the process of fabrication, he recaptures in drawing the immediacy of a one-to-one relationship with his work. Though his drawings are often the first visualization of an idea that might appear later in a large sculptural piece, they possess attributes that qualify them as finished, independent works with their own merit.

Hunt values line as one of the most crucial components of his sculptural compositions, and its importance is equally evident in his works on paper. If we follow the development of his drawings from the monolithic shapes describing his waterfalls of the late 1970s to his recent works, we witness the continuous liberation of line from a subservient role toward complete autonomy. The drawings from his recent *Barcelona* series were designed as a public commission for Barcelona's Parque del Clot and are the largest he has executed to date.

Selected Individual Exhibitions

1975
Palais des Beaux-Arts, Brussels

1977
Blum Helman Gallery, New York

1979
Galerie Bruno Bischofberger, Zurich

1981
Akron Art Museum, Ohio

1982
Bernier Gallery, Athens, Greece

1983
Blum Helman Gallery, New York. Catalogue, with text by Carter Ratcliff

Los Angeles County Museum of Art

The University Art Museum, California State University, Long Beach. Catalogue edited by Constance W. Glenn and Jane K. Bledsoe

1984
Knoedler Zürich, Zurich. Catalogue, with text by Barbara Haskell

1985
Blum Helman Gallery, New York

1986
Gillespie-Laage-Salomon, Paris

Akira Ikeda Gallery, Tokyo

Selected Group Exhibitions

1977
P.S.1, The Institute for Art and Urban Resources, Long Island City, New York, *Projects of the Seventies: New York Avant-Garde*

1978
The Solomon R. Guggenheim Museum, New York, *Young American Artists*. Catalogue, with text by Linda Shearer

Stedelijk Museum, Amsterdam, *Made by Sculptors/Door Beeldhouwers Gemaakt*. Catalogue, with text by Rini Dippel and Geert van Biejeren

1979
Whitney Museum of American Art, New York, *1979 Biennial Exhibition*. Catalogue

1980
San Francisco Museum of Modern Art, *20 American Artists*. Catalogue, with text by Henry T. Hopkins

La Biennale di Venezia, Venice, *Art in the Seventies: Open '80*

1981
Cleveland Museum of Art, *Contemporary Artists*. Catalogue, with text by Tom E. Hinson

1982
Hayden Gallery, Massachusetts Institute of Technology, Cambridge, *Great Big Drawings: Contemporary Works on Paper*. Catalogue, with text by Katy Kline

1983
The Art Museum of the Ateneum, Helsinki, *Ars '83*. Catalogue, with text by Leena Peltola

1984
The Museum of Modern Art, New York, *An International Survey of Recent Painting and Sculpture*. Catalogue

1985
Whitney Museum of American Art, New York, *1985 Biennial Exhibition*. Catalogue

1986
The Museum of Modern Art, New York, *Sculptors' Drawings*

Selected Bibliography

1977
Jeff Perrone. "Bryan Hunt: Blum Helman Gallery." *Artforum*, vol. 15, no. 10 (Summer 1977), p. 68.

1979
Dupuy Warrick Reed. "Bryan Hunt." *Arts Magazine*, vol. 53, no. 8 (April 1979), p. 7.

1980
Melinda Wortz. "Los Angeles: Hieroglyphic Umbrellas." *Art News*, vol. 79, no. 5 (May 1980), p. 141.

1981
Dupuy Warrick Reed. "Bryan Hunt." *Flash Art* (Milan), no. 104 (October–November 1981), pp. 49–50.

1983
Constance W. Glenn. "Artist's Dialog: A Conversation with Bryan Hunt." *Architectural Digest* (Los Angeles), vol. 40, no. 3 (March 1983), pp. 68–74.

1984
John Robinson. "Francesco Clemente/Bryan Hunt/David Salle." *Arts Magazine*, vol. 59, no. 1 (September 1984), p. 34.

1985
Loïc Malle. "Bryan Hunt: classicisme et abstraction." Interview. *Art Press* (Paris), no. 91 (April 1985), pp. 20–23.

Vivien Raynor. "Bryan Hunt." *The New York Times*, May 10, 1985, p. C26.

1986
Harvey Stein. *Artists Observed*. New York: Harry N. Abrams.

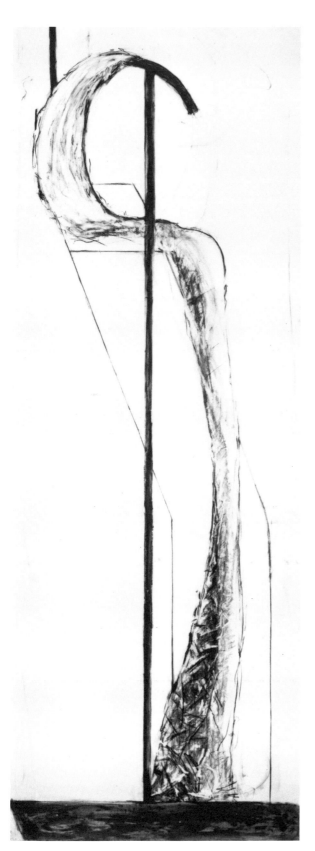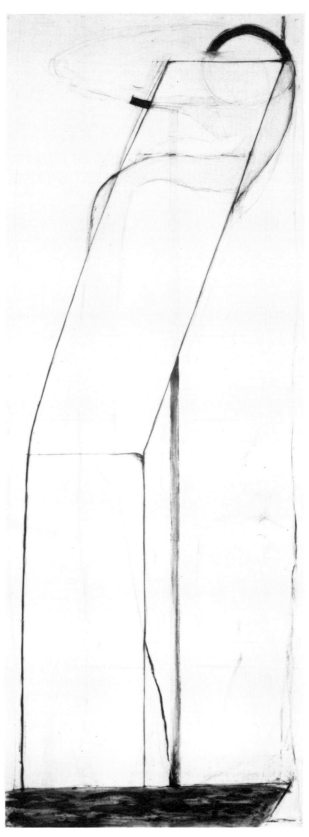

BRYAN HUNT
*Working Drawing for Barcelona Project—Rite of
 Spring—Left*, 1986
Graphite and oil stick on paper, 168 x 60 inches
Collection of the artist

*Working Drawing for Barcelona Project—Rite of
 Spring—Right*, 1986
Graphite and oil stick on paper, 168 x 60 inches
Collection of the artist

ROBERT LONGO

Born 1953 in Brooklyn

B.F.A. 1975, State University of New York
College at Buffalo

Resides in New York

Robert Longo has been working on *Men in the Cities,* a series of large-sized drawings, since 1975; from 1977 to 1982 it was his principal artistic preoccupation. At the inception of the series he drew single images of formally dressed men isolated in white blankness. Images of women followed, and, after investigation of the single figure, he decided to group them. The drawings depict Longo's friends and associates arrested in particular movements by the shutter of his camera. They are monumental in scale and contemporary in content, describing the pressure, tension, frenzy, and loneliness inherent in our age.

Although now involved with painting and very much with sculpture, both relief and in the round, Longo maintains his allegiance to drawing. ''Drawing when I was a kid was an escape for me,'' he says, ''and now as an adult it's a profession. I always draw. I've always drawn. I love the line that comes from the hand, it's real power. . . . My drawings are like sculpture: when I draw with graphite I smudge it with my fingers, move it around physically; it's like clay. Painting is painting on the surface, covering up, where drawing is putting the picture into the paper like a photograph.''*

*Richard Price, ''Save the Last Dance for Me,'' in *Men in the Cities* (New York: Harry N. Abrams, 1986), p. 95.

Selected Individual Exhibitions

1976
HALLWALLS, Buffalo

1979
The Kitchen, New York

1981
Metro Pictures, New York

Larry Gagosian Gallery, Los Angeles

1983
Leo Castelli Gallery, New York

1984
Akron Art Museum, Ohio. Catalogue, with introduction by I. Michael Danoff and text by Hal Foster

1985
The Brooklyn Museum

1986
Metro Pictures, New York

Selected Group Exhibitions

1977
Albright-Knox Art Gallery, Buffalo, *In Western New York.* Catalogue

Artists Space, New York, *Pictures.* Traveled. Catalogue, with text by Douglas Crimp

1980
Contemporary Arts Museum, Houston, *Extensions: Jennifer Bartlett, Lynda Benglis, Robert Longo, Judy Pfaff.* Catalogue, with text by Linda L. Cathcart

1981
Museen der Stadt Köln, Cologne, West Germany, *Westkunst: Heute.* Catalogue, with text by Kasper Koenig

Hayden Gallery, Massachusetts Institute of Technology, Cambridge, *Body Language: Figurative Aspects of Recent Art.* Traveled. Catalogue, with text by Roberta Smith

1982
Whitney Museum of American Art, New York, *Focus on the Figure: Twenty Years.* Catalogue, with text by Barbara Haskell

Milwaukee Art Museum, *New Figuration in America.* Catalogue, with text by Russell Bowman and Peter Schjeldahl

1983
Whitney Museum of American Art, New York, *1983 Biennial Exhibition.* Catalogue

Stedelijk van Abbemuseum, Eindhoven, Netherlands, *Dahn, Daniels, Genzken, Holzer, Longo, Visch.* Catalogue, with text by R. H. Fuchs

1984
The Museum of Modern Art, New York, *An International Survey of Recent Painting and Sculpture.* Catalogue

The Museum of Contemporary Art, Los Angeles, *Automobile and Culture.* Traveled. Catalogue

1985
ARCA, Marseilles, France, *New York 85*

Selected Bibliography

1977
Valentin Tatransky. ''Pictures.'' *Arts Magazine,* vol. 52, no. 4 (December 1977), p. 17.

1979
RoseLee Goldberg. *Performance: Live Art, 1909 to the Present.* New York: Harry N. Abrams.

Douglas Crimp. ''Pictures.'' *October* (Cambridge, Massachusetts), no. 8 (Spring 1979), pp. 75–88.

1980
Craig Owens. ''The Allegorical Impulse: Toward a Theory of Postmodernism.'' *October,* no. 12 (Spring 1980), pp. 67–86.

Jeanne Siegel. ''Lois Lane and Robert Longo: Interpretations of Image.'' *Arts Magazine,* vol. 55, no. 3 (November 1980), pp. 154–57.

1981
Carter Ratcliff. ''The Distractions of Theme.'' *Art in America,* vol. 69, no. 9 (November 1981), pp. 19–22.

1982
Helen Kontova. ''From Performance to Painting.'' *Flash Art* (Milan), no. 106 (February–March 1982), p. 20.

1983
Tricia Collins and Richard Milazzo. ''Robert Longo: Static Violence.'' *Flash Art,* no. 112 (May 1983), pp. 36–38.

Carter Ratcliff. ''Robert Longo: The City of Sheer Image.'' *The Print Collector's Newsletter,* vol. 14, no. 3 (July–August 1983), p. 95.

1984
Phyllis Freeman, et al., eds. *New Art.* New York: Harry N. Abrams.

Holland Cotter. ''Robert Longo.'' *Arts Magazine,* vol. 59, no. 1 (September 1984), p. 7.

1985
Paul Gardner. ''Longo: Making Art for Brave Eyes.'' *Art News,* vol. 84, no. 5 (May 1985), pp. 56–65.

1986
Richard Price. ''Save the Last Dance for Me.'' Introduction and interview. *Men in the Cities.* New York: Harry N. Abrams.

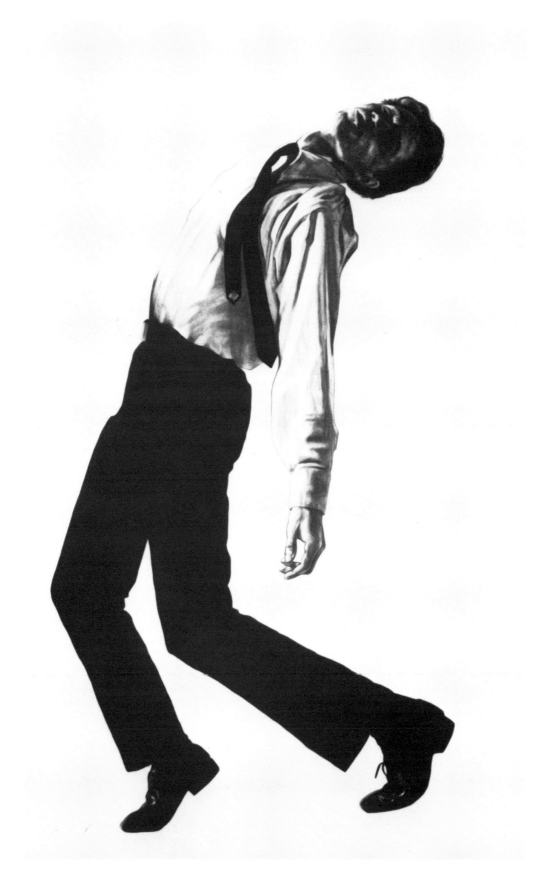

ROBERT LONGO
Men in the Cities, 1981–86
Charcoal and graphite on paper, 96 x 60 inches
Collection of Richard Price

27

ROBERT MOSKOWITZ

Born 1935 in New York

Resides in New York

Formal beauty and complex metaphors characterize the work of Robert Moskowitz. His recent drawings, predominantly large verticals derived from recognizable images of the world of art or the environment, are icons in their own right. His drawing of Rodin's *Thinker*, for instance, is outlined in a hard-edged, angular manner that adds even more psychological and physical weight to the already "overloaded" original. Moskowitz reduces the three-dimensional work to two dimensions without sacrificing any of its original monumentality; indeed it has become even more ponderous, for one cannot escape thinking of Michelangelo's weighty figures while contemplating this image.

In *Giacometti Piece*, Moskowitz accentuates the soaring shape of an anorexic figure. Reduced to almost a single line, more an idea than an actual presence, this drawing has a decidedly abstract quality. There is an affinity here with the artist's *Seventh Sister*, an earlier drawing in which a single line dissects the surface of the piece, and through this piece connections can be established to the work of painters like Barnett Newman, whom Moskowitz greatly admires.

Selected Individual Exhibitions

1977
The Clocktower, The Institute for Art and Urban Resources, New York

1979
Daniel Weinberg Gallery, San Francisco. Traveled

1980
Margo Leavin Gallery, Los Angeles. Traveled

1981
Walker Art Center, Minneapolis. Traveled. Brochure, with text by Lisa Lyons

1983
Blum Helman Gallery, New York. Catalogue, with text by Robert Rosenblum

Portland Center for the Visual Arts, Oregon

1986
Blum Helman Gallery, New York. Catalogue, with text by Katy Kline

Selected Group Exhibitions

1973
Whitney Museum of American Art, New York, *1973 Biennial Exhibition*. Catalogue

1976
Paula Cooper Gallery, New York

1978
Albright-Knox Art Gallery, Buffalo, *American Paintings of the 1970s*. Traveled. Catalogue, with text by Linda L. Cathcart

Whitney Museum of American Art, New York, *New Image Painting*. Catalogue, with text by Richard Marshall

1979
Grey Art Gallery and Study Center, New York University, *American Painting: The Eighties, A*

Critical Interpretation. Catalogue, with text by Barbara Rose

1980
La Biennale di Venezia, Venice, *Art in the Seventies: Open '80*

1981
Kunsthalle Basel, Switzerland, *Robert Moskowitz, Susan Rothenberg and Julian Schnabel*. Traveled. Catalogue, with text by Peter Blum and Michael Hurson

1982
Hayden Gallery, Massachusetts Institute of Technology, Cambridge, *Great Big Drawings: Contemporary Works on Paper*. Catalogue, with text by Katy Kline

1984
The Museum of Modern Art, New York, *An International Survey of Recent Painting and Sculpture*. Catalogue

1985
The Museum of Modern Art, New York, *Contemporary Works from the Collection*

1986
Whitney Museum of American Art at Equitable Center, New York, *Figure as Subject: The Last Decade*

Selected Bibliography

1974
Jeremy Gilbert-Rolfe. "Robert Moskowitz: Nancy Hoffman Gallery." *Artforum*, vol. 12, no. 6 (February 1974), p. 68.

1977
William Zimmer. "Captured Dirt." *SoHo Weekly News*, October 27, 1977, pp. 27ff.

1978
Thomas Lawson. "Robert Moskowitz at the Clocktower." *Art in America*, vol. 66, no. 3 (May–June 1978), p. 115.

1979
David Salle. "New Image Painting." *Flash Art* (Milan), no. 88 (March–April 1979), pp. 40–41.

1980
Michael Compton. "Art and Responsibility." *Flash Art*, nos. 98–99 (Summer 1980), pp. 10–11.

1981
Duane Stapp. "Robert Moskowitz: Blum Helman." *Arts Magazine*, vol. 56, no. 3 (November 1981), pp. 18–19.

1982
H. Zellweger. "Americanische Kunst der Achtziger Jahre." *Das Kunstwerk* (Stuttgart, West Germany), vol. 35, no. 1, p. 25.

1983
Prudence Carlson. "Building, Statue, Cliff." *Art in America*, vol. 71, no. 5 (May 1983), pp. 144–47.

Carter Ratcliff. "Manet et l'Amérique." *Art Press* (Paris), no. 72 (July–August 1983), pp. 20–22.

1984
Phyllis Freeman, et al., eds. *New Art*. New York: Harry N. Abrams.

1986
Michael Brenson. "Art: Moskowitz's View of Sculptural and Architectural Icons." *The New York Times*, February 14, 1986, p. C32.

Eleanor Heartney. "Robert Moskowitz—Blum Helman." *Art News*, vol. 85, no. 6 (Summer 1986), p. 145.

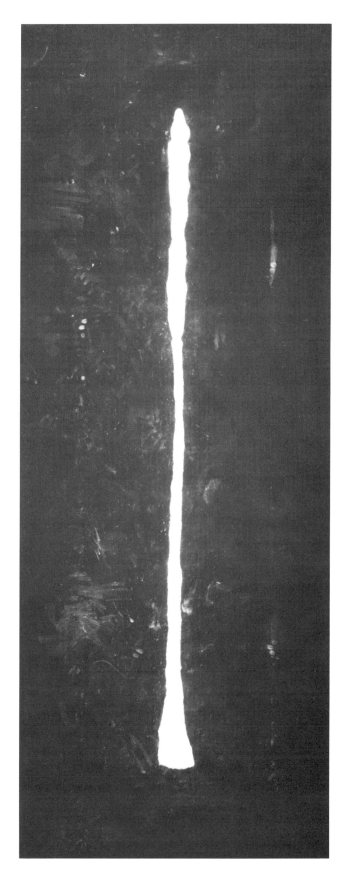

ROBERT MOSKOWITZ
Giacometti Piece (for Bob Holman), 1984
Pastel on paper, 108 x 41⁹⁄₁₆ inches
Collection of the artist

BRUCE NAUMAN

Born 1941 in Fort Wayne, Indiana

B.S. 1964, University of Wisconsin, Madison;
M.F.A. 1966, University of California, Davis

Resides in Pecos, New Mexico

An exceptionally inventive and influential artist for almost two decades, Bruce Nauman has produced hundreds of drawings as a record of his diverse ideas and as preparatory sketches for his various projects in a host of other media. These works on paper clearly reveal the progression of his thoughts and his ability to develop concepts. Although frequently quickly drawn, they are always marked by a sureness of line and gesture—a sign of the clarity of his initial ideas. Nauman has always been fascinated with words and the undisclosed, or secondary, meanings they take on through juxtaposition with other words. Known from the beginning of his career for his inventiveness and wit, he has sharpened his social commentary with the passage of time, achieving a greater understanding of the human condition.

Selected Individual Exhibitions

1975
Leo Castelli Gallery, New York

Albright-Knox Art Gallery, Buffalo

1976
Sperone Westwater Fischer, New York

Sonnabend Gallery, New York

1978
The Minneapolis Institute of Arts

1979
Galerie Schmela, Düsseldorf, West Germany

1981
Rijksmuseum Kröller-Müller, Otterlo, Netherlands. Traveled. Catalogue

1982
The Baltimore Museum of Art. Catalogue, with text by Brenda Richardson

1983
Museum Haus Esters, Krefeld, West Germany

1985
Leo Castelli Gallery, New York

1986
Kunsthalle Basel, Switzerland

Selected Group Exhibitions

1976
The Museum of Modern Art, New York, *Drawing Now*. Traveled. Catalogue, with text by Bernice Rose

1977
Whitney Museum of American Art, New York, *1977 Biennial Exhibition*. Catalogue

1978
Whitney Museum of American Art, New York,

20th Century American Drawings: Five Years of Acquisitions. Catalogue, with text by Paul Cummings

Stedelijk Museum, Amsterdam, *Made by Sculptors/Door Beeldhouwers Gemaakt*. Catalogue, with text by Rini Dippel and Geert van Biejeren

1979
P.S. 1, The Institute for Art and Urban Resources, Long Island City, New York, *Great Big Drawing Show*

1980
The Brooklyn Museum, *American Drawing in Black and White: 1970-1980*. Catalogue

1981
Los Angeles County Museum of Art, *Seventeen Artists in the Sixties*. Traveled. Catalogue

1982
The Art Institute of Chicago, *74th American Exhibition*. Catalogue, with text by Anne Rorimer

1983
Blum Helman Gallery, New York, *John Duff, Robert Mangold, Bruce Nauman*

1984
Los Angeles County Museum of Art, *Selections from the Collection: A Focus on California*

1985
Whitney Museum of American Art, New York, *1985 Biennial Exhibition*. Catalogue

The Museum of Modern Art, New York, *New York on Paper 3*. Catalogue, with text by Bernice Rose

1986
The Museum of Modern Art, New York, *Sculptors' Drawings*

Selected Bibliography

1976
Janet Kutner. "The Visceral Aesthetic of a New Decade's Art." *Arts Magazine*, vol. 51, no. 4 (December 1976), pp. 100-3.

1977
Kenneth Baker. "Bruce Nauman at Castelli, Sonnabend and Sperone Westwater Fischer." *Art in America*, vol. 65, no. 2 (March–April 1977), pp. 111-12.

1979
Gail Stavitsky. "California in Print-1, A Series." *Artweek* (Oakland, California), vol. 10, no. 16 (April 21, 1979), p. 1ff.

1981
Susie Kalil. [B. Nauman, Texas Gallery, reviewed.] *Art News*, vol. 80, no. 9 (November 1981), pp. 182ff.

1983
Christopher French. "The Slant Step Reappears." *Artweek*, vol. 14, no. 4 (January 29, 1983), pp. 1ff.

Richard Armstrong. "John Duff, Robert Mangold, Bruce Nauman, Blum Helman Gallery." *Artforum*, vol. 22, no. 1 (September 1983), pp. 68–69.

1985
Nancy Princenthal. "Bruce Nauman—Sperone Westwater and Leo Castelli." *Art News*, vol. 84, no. 1 (January 1985), p. 137.

Ronald Jones. "Bruce Nauman." *Arts Magazine*, vol. 59, no. 6 (February 1985), p. 4.

1986
Coosje Van Bruggen. "Entrance, Entrapment, Exit: The Process of Bruce Nauman." *Artforum*, vol. 24, no. 10 (Summer 1986), pp. 88–97.

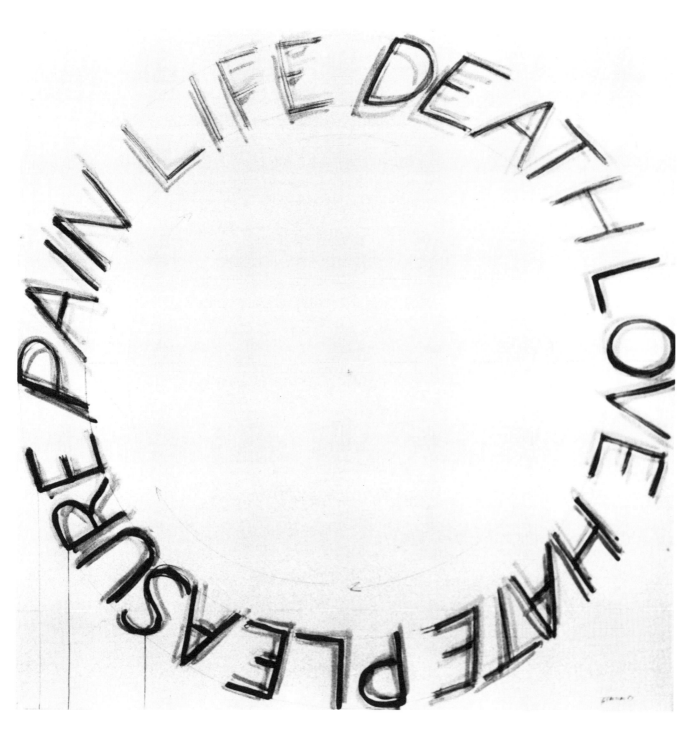

BRUCE NAUMAN
Life, Death, Love, Hate, Pleasure, Pain, 1983
Watercolor, pastel, pencil, and charcoal on
 paper, 80 x 80 inches
Leo Castelli Gallery, New York

JOHN NEWMAN

Born 1952 in New York

Participated 1972 in Independent Study Program, Whitney Museum of American Art, New York

B.A. 1973, Oberlin College, Ohio; M.F.A. 1975, Yale University, New Haven, Connecticut

Resides in New York

The composition of John Newman's large drawings evolves around a large central shape frequently destined to become a sculptural piece at a later date. Truly statuesque and commanding in its aggressively kinetic presence, this central figure is surrounded by a fleet of smaller orbiting elements. Some of these elements echo the structure of the main shape, spinning off into infinite space; some could be the seeds and pods of primeval flora; and some are exercises in trigonometry. All are indispensable: they are conceptual and formal counterparts of the central image, and their multiplicity reveals Newman's imagination and compositional skills.

Newman's work is informed by his interest in philosophy, non-Euclidean geometry, linguistics, history, theoretical physics, and the structure and origins of the universe. Any attempt to categorize his art would defy one of its main characteristics—the coexistence of formal opposites. In his work the geometric is transformed into the organic, while the organic reveals its essential geometric structure. The investigation of the curve and its infinite application in linear and volumetric systems, that is in two- and three-dimensional forms, continues to be Newman's major area of concern, permeating all his work.

Selected Individual Exhibitions

1977
Center for Advanced Visual Studies, Massachusetts Institute of Technology, Cambridge

1979
Thomas Segal Gallery, Boston

1981
Reed College Art Gallery, Portland, Oregon

1985
Daniel Weinberg Gallery, Los Angeles

Selected Group Exhibitions

1975
112 Greene Street Gallery, New York, *Sculpture and Drawings*

1978
Worcester Art Museum, Massachusetts, *Between Painting and Sculpture*

1979
Institute of Contemporary Art, Boston, *Six Sculptors*

Hayden Gallery, Massachusetts Institute of Technology, Cambridge, *Corners: Painterly and Sculptural Work*. Catalogue, with text by Kathy Halbreich

1980
Whitney Museum of American Art, Downtown Branch, New York, *Painting in Relief*

1983
Baskerville + Watson Gallery, New York, *Drawing It Out*

1984
Barbara Toll Fine Arts, New York, *Drawings*

1985
Whitney Museum of American Art, New York, *1985 Biennial Exhibition*. Catalogue

Diane Brown Gallery, New York, *Sculptors' Drawings*

1986
Phillip Dash Gallery, New York, *Movements: An Exhibit of Geometric Abstraction*

Jeffrey Hoffeld & Co., New York, *Drawings: Carroll Dunham, John Newman & Terry Winters*

Selected Bibliography

1980
Ronald J. Onorato. "'Corners,' Hayden Gallery, M.I.T." *Artforum*, vol. 18, no. 5 (January 1980), pp. 82–83.

1981
Robert Pincus-Witten. "Entries: Sheer Grunge." *Arts Magazine*, vol. 55, no. 9 (May 1981), pp. 93–97.

1983
Gerrit Henry. "The New Sculpture—Hamilton." *Art News*, vol. 82, no. 8 (October 1983), p. 188.

1985
Wade Saunders. "Talking Objects: Interviews with Ten Younger Sculptors." *Art in America*, vol. 73, no. 11 (November 1985), pp. 128–29.

1986
Robert Mahoney. "John Newman/Carroll Dunham." *Arts Magazine*, vol. 60, no. 10 (Summer 1986), p. 127.

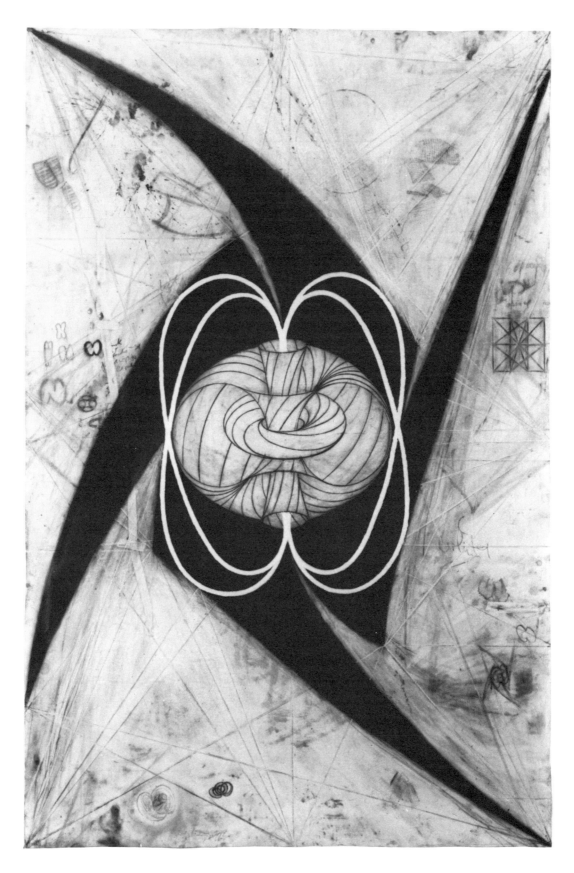

JOHN NEWMAN
Untitled (Nested Tori), 1985
Chalk, oil stick, and graphite on paper, 92 x 60 inches
Collection of Edward R. Downe, Jr.

DIANE OLIVIER

Born 1955 in Central Falls, Rhode Island

B.F.A. 1978, Rhode Island School of Design, Providence; M.A. 1983, San Jose State University, California; M.F.A. 1984, University of California, Berkeley

Resides in Cincinnati, Ohio

Diane Olivier was trained as a painter, but her interest has always gravitated toward drawing, and she has devoted herself to the medium since her move to California in 1980. After she settled in Oakland, the Bay Area became her greatest stimulation. It was her first experience of living in a large city, and she was spellbound by the architecture. ''Up to this point I had dealt exclusively with the human figure,'' she says. ''I now decided to remove the figure and concentrate on its surroundings. The many buildings being demolished in San Francisco caught my attention from the first day I moved to the Bay Area. They became my new subject, and the pieces became larger as I developed the theme. It seemed to go hand in hand with the scale of the city as well as allowing me even more of the physical contact I enjoyed in drawing.''*

*Pro Arts 1985 Juried Exhibition, exhibition catalogue (University of California at Berkeley, December 1, 1985–January 15, 1986), p. 18.

Selected Group Exhibitions

1984
San Francisco Art Commission Gallery, Line/Gesture/Dimension: Drawings by Five Bay Area Artists

1985
Dorothy Weiss Gallery, San Francisco, Introductions '85

Everson Museum of Art, Syracuse University, New York, Drawing National. Traveled. Catalogue, with text by Clement Greenberg and John Perreault

1986
Dorothy Weiss Gallery, San Francisco

Selected Bibliography

1984
J. Burstein Hays. ''Drawing Broadly Defined.'' Artweek (Oakland, California), vol. 15, no. 34 (October 13, 1984), pp. 7–8.

1985
Andrea Liss. ''Introductions '85.'' Art News, vol. 84, no. 8 (October 1985), p. 115.

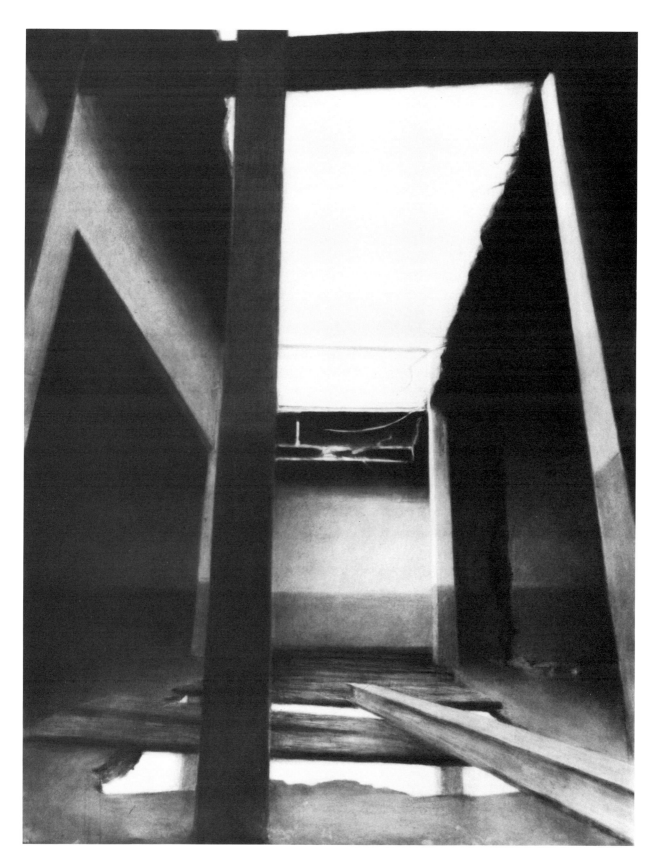

DIANE OLIVIER
Open Room, 1985
Charcoal on paper, 80 x 62 inches
Collection of Jolene and Andrew Andoniadis,
 courtesy of Dorothy Weiss Gallery, San Francisco

ELFI SCHUSELKA

Born 1940 in Vienna

Studied at the Graphic and Experimental Institute of Vienna, the University of Vienna, and the Academy of Applied Arts, Vienna

Resides in New York

Elfi Schuselka's *Samen und Keime #5 (Seeds and Pods #5)* reflects the artist's search for universal beginnings. Its energetically drawn shapes, both biomorphic and geometric, are tightly organized into seeming disorder. *Climbing Parnassus #26* and *#27,* on the other hand, belong to an ongoing series based on an idea that likens the act of creating with that of attempting to climb Mount Parnassus, the mountain of Apollo and the Muses—that is of wanting to be with or have the perceptions of the gods.

My primary interest in the theme is that it serves to liberate me for the total involvement in the process of painting or drawing. Other themes could and sometimes do serve the same purpose, but I enjoy this metaphor because although I find it somewhat pretentious of artists, including myself, to entertain such lofty notions, I am at the same time convinced that creative involvements do in fact serve to bring us all a step or two up the mountain.

I try to stay on an edge between retaining and losing control, which helps to express a quality of implicitness. Childlike scribbles, canceled passages, color tracks, hints of flight, symbols and images just short of being, ambiguous shapes, paradoxical spaces—all suggest transient maybes and a never-ending energetic and restless universe that simultaneously comes into and goes out of existence. *

*Condeso/Lawler Gallery Report 30 (New York, March 26, 1985), unpaginated.

Selected Individual Exhibitions

1977
55 Mercer Gallery, New York

1980
Condeso/Lawler Gallery, New York

1984
55 Mercer Gallery, New York

1985
Condeso/Lawler Gallery, New York

1986
American Center, Belgrade, Yugoslavia. Traveled

Selected Group Exhibitions

1976
The Brooklyn Museum, *30 Years of American Printmaking, Including the 20th National Print Exhibition.* Catalogue, with text by Gene Baro

1978
Aldrich Museum of Contemporary Art, Ridgefield, Connecticut, *Contemporary Reflections*

1980
Austrian Institute, New York, *Four Austrians in New York*

1982
Modern Gallery, Rijeka, Yugoslavia, *International Exhibition of Graphic Art*

Castle Gallery, College of New Rochelle, New York, *Selected Women Painters*

1984
Modern Gallery, Rijeka, Yugoslavia, *International Exhibition of Original Drawings*

P.S. 122, New York, *Large Format Drawings*

1985
Institut Autrichien, Paris, *Spektrum '85*

Selected Bibliography

1978
Tiffany Bell. "Elfi Schuselka: 55 Mercer." *Arts Magazine,* vol. 52, no. 5 (January 1978), p. 23.

1982
Vivien Raynor. [*Selected Women Painters* at Castle Gallery, College of New Rochelle, reviewed.] *The New York Times,* December 26, 1982, section XXII, p. 16.

1985
Grace Glueck. [E. Schuselka, Condeso/Lawler Gallery, reviewed.] *The New York Times,* March 29, 1985, section III, p. 28.

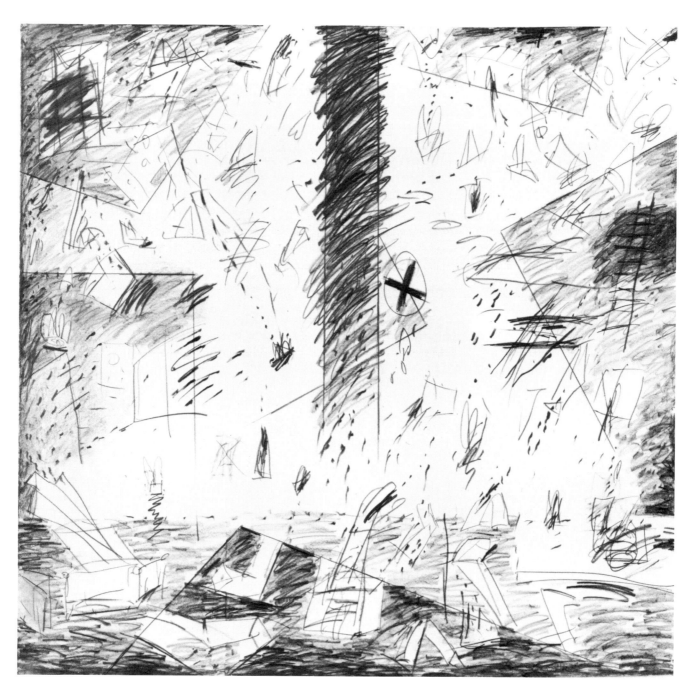

ELFI SCHUSELKA
Climbing Parnassus #26, 1985–86
Graphite on paper, 58 x 60 inches
Collection of the artist

RICHARD SERRA

Born 1939 in San Francisco

B.A. 1961, University of California, Santa Barbara; M.F.A. 1964, Yale University, New Haven, Connecticut

Resides in New York

For Richard Serra drawing has always been of prime importance. His drawings constitute some of the most important statements in the visual arts in the past two decades. According to Serra:

Drawing is a way of seeing into your own nature. Nothing more. There are certain processes that one learns, learned methods, that end up being a hindrance. There is no way to make a drawing; there is only drawing. . . . To draw a line is to have an idea. More than one line is usually constructing. Ideas become compounded as soon as you make the second line. Drawing is a way for me to carry on an interior monologue in the making as I am making it. . . . What I continually find to be true is that the concentration I apply to drawing is a way of training, or honing, my eye. The more I draw, the better I see and the more I understand. There has always been a correlation between the strength of the work and the degree to which I am drawing. *

In *Slat*, one of Serra's most recent drawings, he positions a large, dark shape at a precarious angle, suggesting a shifting equilibrium. This seeming instability of a monolithic presence creates a dramatic bravado in most of Serra's work.

*Quoted in Lizzie Borden, "Richard Serra," in *Richard Serra: Drawing 1971–1977*, exhibition catalogue (Amsterdam: Stedelijk Museum, 1977), p. 87.

Selected Individual Exhibitions

1977
Stedelijk Museum, Amsterdam. Traveled

1978
Ace Gallery, Venice, California

Blum Helman Gallery, New York

1979
Matrix Gallery, University Art Museum, University of California, Berkeley

1980
The Hudson River Museum of Westchester, Yonkers, New York

1981
KOH Gallery, Tokyo

1982
The Saint Louis Art Museum

1983
Musée Nationale d'Art Moderne, Centre Georges Pompidou, Paris. Catalogue, with text by Yve-Alain Bois and Rosalind E. Krauss

1984
Leo Castelli Gallery, New York

1985
Museum Haus Lange, Krefeld, West Germany. Catalogue, with text by Marianne Stockebrand

Akira Ikeda Gallery, Tokyo

1986
The Museum of Modern Art, New York. Catalogue, with text by Rosalind E. Krauss and Douglas Crimp

Selected Group Exhibitions

1976
The Museum of Modern Art, New York, *Drawing*

Now. Traveled. Catalogue, with text by Bernice Rose

1977
The New York State Museum, Albany, *New York: The State of Art.* Catalogue

1978
Whitney Museum of American Art, New York, *20th Century American Drawings: Five Years of Acquisitions.* Catalogue, with text by Paul Cummings

1979
P.S. 1, The Institute for Art and Urban Resources, Long Island City, New York, *Great Big Drawing Show*

1980
The Brooklyn Museum, *American Drawing in Black and White: 1970–1980.* Catalogue

1981
Sewall Art Gallery, Rice University, Houston, *Variants: Drawings by Contemporary Sculptors.* Traveled. Catalogue, with text by Laura W. Russell

1983
The Art Museum of the Ateneum, Helsinki, *Ars '83.* Catalogue, with text by Leena Peltola

1984
Zilkha Gallery, Wesleyan University, Middletown, Connecticut, *Large Drawings*

1985
Museum of Art, Carnegie Institute, Pittsburgh, *Carnegie International*

1986
The Museum of Modern Art, New York, *Sculptors' Drawings*

Selected Bibliography

1978
Jeff Perrone. "Richard Serra, Blum Helman Gallery." *Artforum*, vol. 17, no. 4 (December 1978), pp. 69–70.

1979
Regina Cornwell. "Three by Serra." *Artforum*, vol. 18, no. 4 (December 1979), pp. 28–32.

1980
Robert Pincus-Witten. "Entries: Oedipus Reconciled." *Arts Magazine*, vol. 55, no. 3 (November 1980), pp. 130–33.

1981
Douglas Crimp. "Richard Serra: Sculpture Exceeded." *October* (Cambridge, Massachusetts), no. 18 (Fall 1981), pp. 67–78.

1982
Don Hawthorne. "Does the Public Want Public Sculpture?" *Art News*, vol. 81, no. 5 (May 1982), pp. 56–63.

1984
Yve-Alain Bois. "The Meteorite in the Garden." *Art in America*, vol. 72, no. 6 (Summer 1984), pp. 108–13.

1985
Robert Storr. "'Tilted Arc': Enemy of the People?" *Art in America*, vol. 73, no. 9 (September 1985), pp. 90–97.

Michael Brenson. "Richard Serra Works Find a Warm Welcome in France." *The New York Times*, November 3, 1985, section 2, pp. 35ff.

1986
John G. Hanhardt, ed. *Video Culture: A Critical Investigation.* Rochester, New York: Visual Studies Workshop Press.

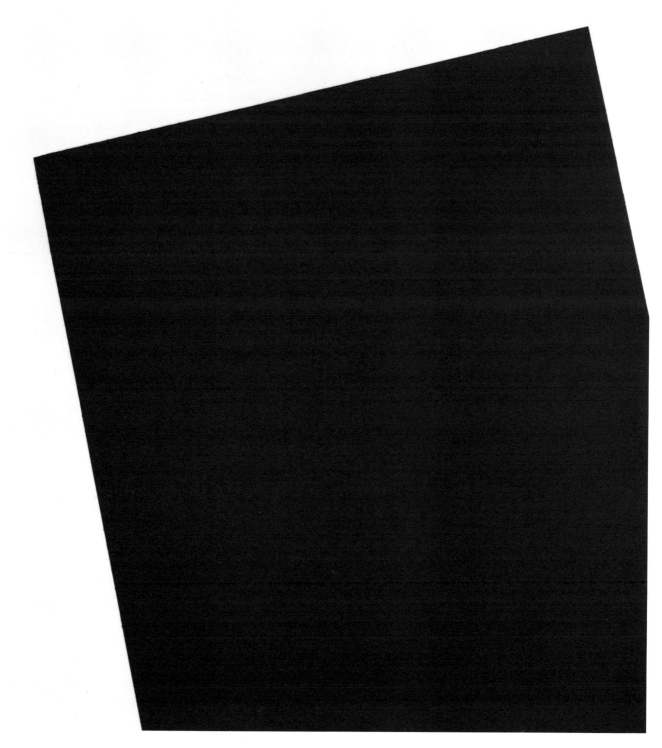

RICHARD SERRA
Slat, 1986
Paint stick on paper, 87⅛ x 79⅞ inches
Collection of REFCO Group Ltd., Chicago

ROBERT STACKHOUSE

Born 1942 in Bronxville, New York

B.A. 1965, University of South Florida, Tampa;
M.A. 1967, University of Maryland, College Park

Resides in New York

Robert Stackhouse's fascinating watercolors are of immense scale. Although connected with his site-specific installations, they are also fully realized works in their own right. Images of ships and passages are pervasive, inviting us to take a journey to the roots of our subconscious. In *Deep Swimmers and Mountain Climbers* a long passage is open in front of us, and we can choose to withdraw from it or explore its depth depending on our own courage and curiosity. As with most of the artist's works, this piece contains allusions to certain Minimalist principles, repeating a single unit in the structure of a long corridor-passage with the expressive use of gesture and color.

Selected Individual Exhibitions

1978
The Hudson River Museum of Westchester, Yonkers, New York

1980
Max Hutchinson Gallery, New York

Nassau County Museum of Fine Arts, Roslyn Harbor, New York. Catalogue, with text by April Kingsley

1984
Australia National Gallery, Canberra

Anderson Gallery, School of the Arts, Richmond Commonwealth University, Virginia

Art and Architecture Gallery, University of Tennessee, Knoxville. Catalogue, with text by Donald Kuspit

1985
Max Hutchinson Gallery, New York

Hunter Museum of Art, Chattanooga, Tennessee

1986
Koplin Gallery, Los Angeles

Selected Group Exhibitions

1975
Moore College Art Gallery, Philadelphia, *North, East, West, South, Middle.* Traveled. Catalogue, with text by Peter Plagens

1977
The Art Institute of Chicago, *Drawings of the '70s*

1978
Artpark, Lewiston, New York, *Artpark 1978.* Catalogue

Cranbrook Academy of Art, Bloomfield Hills, Michigan, *Outdoor Environmental Sculpture*

1979
Joe and Emily Lowe Art Gallery, Syracuse University, New York, *New York 7*

1980
Los Angeles Institute of Contemporary Art, *Architectural Sculptures*

1981
Touchstone Gallery, New York, *Ritual*

1983
The Brooklyn Bridge Anchorage, Brooklyn, *Art in the Anchorage*

P.S. 1, The Institute for Art and Urban Resources, Long Island City, New York, *Couples II*

1984
The Museum of Modern Art, New York, *An International Survey of Recent Painting and Sculpture.* Catalogue

Edith C. Blum Art Institute, Bard College, Annandale-on-Hudson, New York, *Land Marks.* Catalogue

1985
Diane Brown Gallery, New York, *Sculptors' Drawings*

Selected Bibliography

1976
David Bourdon. "Robert Stackhouse: On the Trail of Legend." *Arts Magazine,* vol. 51, no. 4 (December 1976), pp. 104–5.

Phil Patton. "Robert Stackhouse: Sculpture Now." *Artforum,* vol. 15, no. 3 (December 1976), pp. 71–72.

1978
William R. Hegemen. "Minneapolis: Sculpture to Walk Through." *Art News,* vol. 77, no. 1 (January 1978), pp. 115–17.

1980
Edward Lucie-Smith. *Art in the Seventies.* Ithaca, New York: Cornell University Press.

Jerry Herman. "Robert Stackhouse." *Arts Magazine,* vol. 54, no. 10 (June 1980), pp. 34–35.

1981
Corinne Robins. "Sculpture Now, 1974–1979." *Arts Magazine,* vol. 56, no. 3 (November 1981), pp. 142–45.

1983
Valerie Brooks. "Sculpture Invitational." *Flash Art* (Milan), no. 112 (May 1983), p. 66.

Timothy Rub. "Robert Stackhouse: Max Hutchinson." *Arts Magazine,* vol. 58, no. 1 (September 1983), p. 35.

1984
Corinne Robins. *The Pluralist Era: American Art, 1968–1982.* New York: Harper & Row.

1985
Patricia Phillip. "'Land Marks': Edith C. Blum Art Institute, Bard College." *Artforum,* vol. 23, no. 5 (January 1985), pp. 92–93.

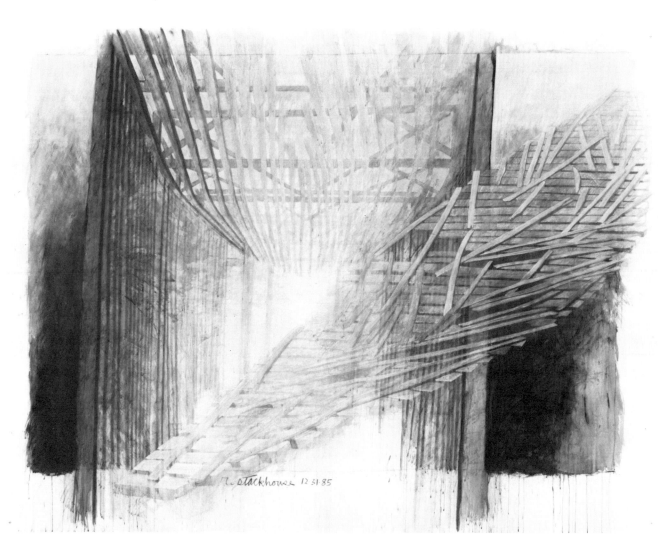

ROBERT STACKHOUSE
Deep Swimmers and Mountain Climbers, 1985
Pencil, charcoal, and watercolor on paper, 90 x 120 inches
Collection of the artist

DONALD SULTAN

Born 1951 in Asheville, North Carolina

B.F.A. 1973, University of North Carolina, Chapel Hill; M.F.A. 1975, School of The Art Institute of Chicago

Resides in New York

Donald Sultan is a painter for whom drawings have become as important as paintings, perhaps because his early paintings were in black and white, a feature that lent itself to translation into graphic media. In his drawings he limits himself to a few subjects—flowers, lemons, and recently eggs. His tulips have an anthropomorphic presence—they appear to be walking personages endowed with both fragility and strength—but they can also be read as black abstract shapes on a white background in a strictly defined figure-ground relationship. His drawings of lemons, on the other hand, are studies in the juxtaposition of equal shapes. Still life has been of great importance to Sultan for many years, and he takes pride in giving it serious and consistent attention.

Selected Individual Exhibitions

1977
Artists Space, New York

P.S. 1, The Institute for Art and Urban Resources, Long Island City, New York

1979
Willard Gallery, New York. Catalogue, with text by Ellen Schwartz

1981
Daniel Weinberg Gallery, San Francisco

1982
Blum Helman Gallery, New York

Hans Strelow Gallery, Düsseldorf, West Germany

1983
Akira Ikeda Gallery, Tokyo. Catalogue

1985
Gian Enzo Sperone, Rome

Barbara Krakow Gallery, Boston. Traveled. Catalogue

1986
Blum Helman Gallery, New York

Selected Group Exhibitions

1977
Institute of Contemporary Art, Tokyo, *Four Artists: Drawings* (exhibition organized by The New Museum of Contemporary Art, New York). Catalogue, with text by Marcia Tucker

1978
University Art Museum, University of California, Santa Barbara, *Contemporary Drawing/New York*. Catalogue, with text by Phyllis Plous

1979
Whitney Museum of American Art, New York, *1979 Biennial Exhibition*. Catalogue

1981
Contemporary Arts Museum, Houston, *The Americans: The Landscape*. Catalogue, with text by Linda L. Cathcart

The High Museum of Art, Atlanta, *Recent Acquisitions: Works on Paper*. Catalogue

1982
Blum Helman Gallery, New York, *Drawings*

1983
The Brooklyn Museum, *The American Artist as Printmaker*. Catalogue, with text by Barry Walker

Museum of Fine Arts, Boston, *Brave New Works: Recent American Painting and Drawing*

1984
The Museum of Modern Art, New York, *An International Survey of Recent Painting and Sculpture*. Catalogue

Walker Art Center, Minneapolis, *Images and Impressions: Painters Who Print*. Catalogue, with text by Martin Friedman, et al.

1985
Holly Solomon Gallery, New York, *Innovative Still Life*

Janie C. Lee Gallery, Houston, *Charcoal Drawings 1880–1985*

Selected Bibliography

1978
Carter Ratcliff. "New York Letter." *Art International* (Lugano, Switzerland), vol. 22, no. 6 (October 1978), p. 55.

1979
Dupuy Warrick Reed. "Donald Sultan: Metaphor for Memory." *Arts Magazine*, vol. 53, no. 10 (June 1979), pp. 148–49.

1980
Richard Whelan. "New Editions: Donald Sultan." *Art News*, vol. 79, no. 3 (March 1980), p. 117.

1981
Kim Levin. "Donald Sultan and Lois Lane." *Flash Art* (Milan), no. 101 (January–February 1981), pp. 49–50.

1983
Steven Henry Madoff. "Donald Sultan at Blum Helman." *Art in America*, vol. 71, no. 1 (January 1983), p. 126.

1984
Phyllis Freeman, et al., eds. *New Art*. New York: Harry N. Abrams

John Russell. "American Art Gains New Energies." *The New York Times*, August 19, 1984, section 2, pp. 1ff.

1985
Calvin Tomkins. "The Art World: Clear Painting." *The New Yorker*, June 3, 1985, pp. 106ff.

1986
Gerrit Henry. "Donald Sultan: His Prints." *The Print Collector's Newsletter*, vol. 16, no. 6 (January–February 1986), pp. 193–96.

Carolyn Christov-Bakargiev. "Donald Sultan." Interview. *Flash Art*, no. 128 (June 1986), pp. 48–50.

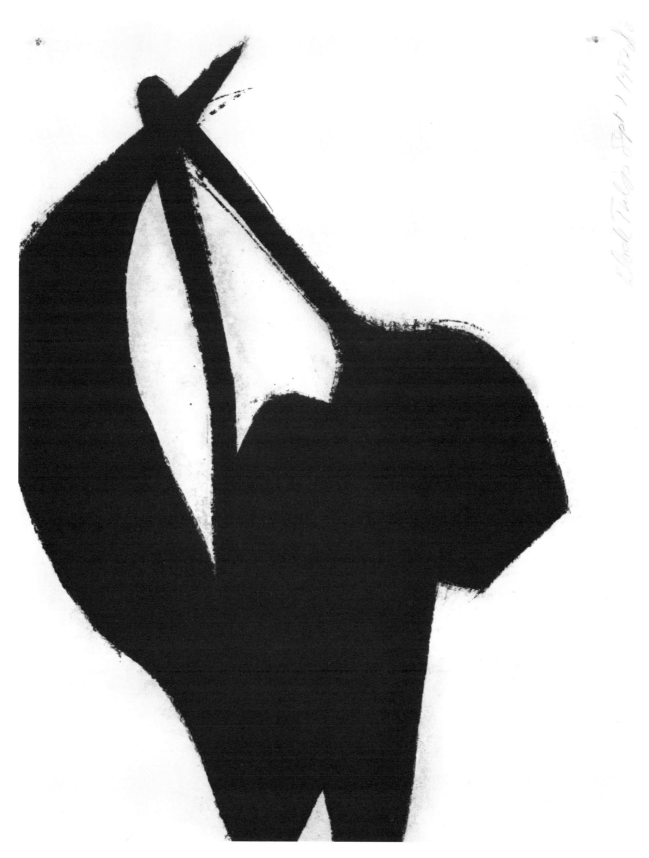

DONALD SULTAN
Black Tulip Sept 1 1983, 1983
Charcoal on paper, 50 x 38 inches
Private collection

ANDREW TOPOLSKI

Born 1952 in Buffalo

B.F.A. 1974, State University of New York
College at Buffalo; M.F.A. 1977, State University
of New York College at Buffalo

Resides in Brooklyn

For Andrew Topolski drawing has always been an essential activity. In the early 1980s his work was characterized by large geometric shapes rendered in primary colors, but lately his pieces have become more complex as he has become interested in the visualization of musical scores. Concerned about the threat of nuclear destruction, he uses these musical compositions in combination with images of structures relating to nuclear power and weapons—missile silos, containment domes, cooling towers, and the like. "My current works focus on sources of architecture in conjunction with nuclear equations and configurations specific to atomic energy," he explains:

Related fragments of design and numerical structures of these sources are plotted on an x-y graph, superimposing one on another. An array of forms is achieved, and a derivative progression of drawings evolves. Integrated within the works is an ongoing musical composition based on these structures and derived from alphabetical and numerical combinations translated into notes and sound masses. The music reiterates the structure of the drawings. The intent is to direct attention to architectural evolution relative to the constant threat of Earth's destruction. *

*Artist's statement, June 1986.

Selected Individual Exhibitions

1979
HALLWALLS, Buffalo

1980
More-Rubin Gallery, Buffalo

1982
Burchfield Center, Buffalo

HALLWALLS, Buffalo

1983
Buscaglia-Castellani Art Gallery, Niagara University, Niagara Falls, New York

Selected Group Exhibitions

1979
Albright-Knox Art Gallery, Buffalo, *In Western New York, 1979.* Catalogue

1980
Alamo Gallery, State University of New York College at Buffalo

1981
Albright-Knox Art Gallery, Buffalo, *In Western New York, 1981.* Catalogue

1983
Memorial Art Gallery, University of Rochester, New York

1984
Buscaglia-Castellani Art Gallery, Niagara University, Niagara Falls, New York, *Recent Acquisitions*

1985
Burchfield Art Center, State University of New York College at Buffalo, *Recent Acquisitions*

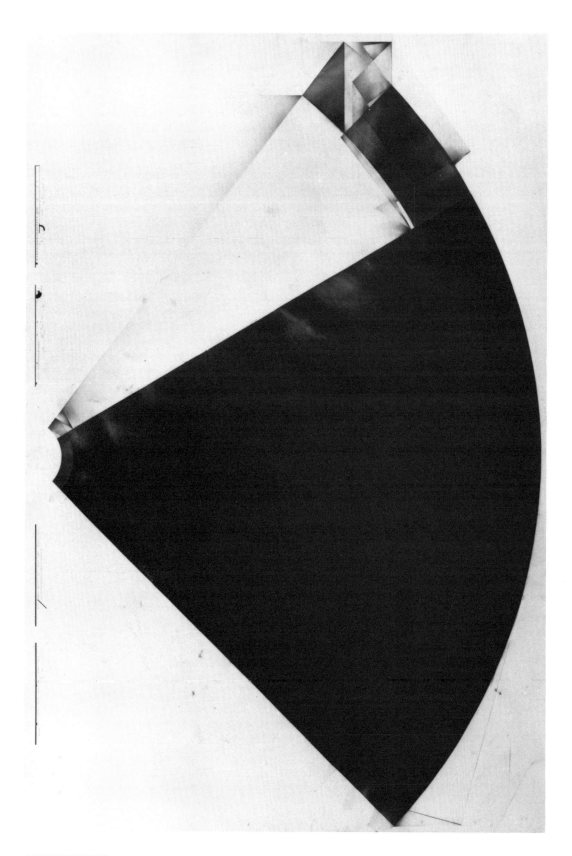

ANDREW TOPOLSKI
A Sound Measure/de-Tonation I–IV, 1986
Carbon, pigment, transfertype, and graphite on
 paper, 4 pieces, 94½ x 63½ inches each
Collection of the artist
(One piece illustrated)

MICHAEL TRACY

Born 1943 in Bellevue, Ohio

B.A. 1964, St. Edwards University, Austin, Texas; studied 1964–66 at Cleveland Art Institute; M.F.A. 1969, The University of Texas at Austin

Resides in San Ygnacio, Texas

Michael Tracy lives in San Ygnacio, Texas, in a part of the country imbued with the Catholic tradition. His early work frequently explored forms tied to Catholic ritual, and his current work is almost always a representation of ecstasy. He frequently describes Catholicism's progressive role in the struggle for human rights in Central America, and he points to the importance of faith in heightening perception. Tracy does not see Catholic dogma as a spiritual experience only; for him, as for the artists of the Counter-Reformation, it is a violently sensual experience. This sensuality, present in all his work, whether figurative or nonrepresentational, is communicated in *Destino Abierto (Open Destiny)* by the gestural layering of paint. The interaction of shapes and intensity of color in this graphic tribute to Mexico make it a dramatic commentary on that country's potential. A versatile artist, Tracy uses performance and sculpture as well as works on paper as his vehicles of expression.

Selected Individual Exhibitions

1977
Roberto Molina Gallery, Houston

1979
A Bon Chat/Bon Rat, Austin, Texas

Museo de Arte Contemporaneo, Ibiza, Spain

1980
Mary Boone Gallery, New York

1983
Contemporary Arts Museum, Houston. Catalogue, with text by Marti Mayo

Delahunty Gallery, New York

1984
Butler Gallery, Houston

Selected Group Exhibitions

1976
Institute of Contemporary Art, University of Pennsylvania, Philadelphia, and Contemporary Arts Museum, Houston, *The Philadelphia-Houston Exchange*. Catalogue

1979
Tiroler Landesmuseum Ferdinandeum, Innsbrook, Austria, *Photographie als Kunst, Kunst als Photographie*

1981
San Antonio Museum of Art, *Off the Wall*. Catalogue, with text by Sally Boothe-Meredith

1983
Tate Gallery, London, *New Art at the Tate Gallery 1983*. Catalogue, with text by Michael Compton

1984
Hirshhorn Museum and Sculpture Garden, Washington, D.C., *Content: A Contemporary Focus, 1974–1984*. Catalogue

1985
Museum of Fine Arts, Houston, *Works on Paper: Eleven Houston Artists*. Catalogue, with text by William A. Camfield

Selected Bibliography

1981
Carter Ratcliff. "Michael Tracy at Mary Boone." *Art in America*, vol. 69, no. 3 (March 1981), p. 128.

1984
William Peterson. "Michael Tracy: Requiem Para Los Olvidados." *Artspace* (Albuquerque), vol. 8, no. 2 (Spring 1984), pp. 33–37.

1985
Thomas McEvilley. "Double Vision in Space City." *Artforum*, vol. 23, no. 8 (April 1985), pp. 52–56.

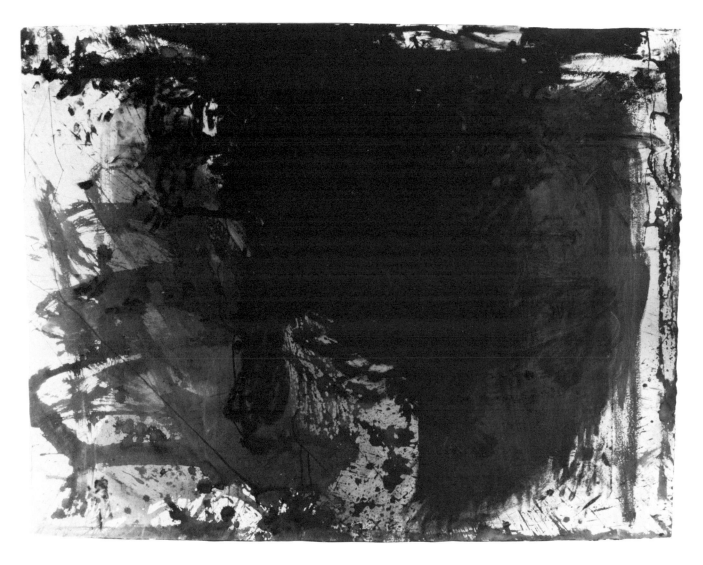

MICHAEL TRACY
From the series *Destino Abierto I–IV, VI, IX*, 1985–86
Watercolor, Cray-Pas, acrylic, oil stick, and
 gouache on paper, 6 panels, 45 x 61 inches each
Hiram Butler Gallery, Houston, and
 Hadler/Rodriguez Gallery, Houston
(Panel III illustrated)

RANDY L. TWADDLE

Born 1957 in Elmo, Missouri

Studied 1975–76 at University of Missouri, Columbia; B.F.A. 1980, Northwest Missouri State University, Maryville

Resides in Dallas

Randy Twaddle is an artist with a political conscience. Often implicit in the images he creates are criticisms of contemporary political and social conditions. *Corporate Imperialism,* a strong example of this type of work, consists of four separate images, each with its own independent identity and set of associations. Each of these images is rendered in exactly the same style: as a stark black silhouette against a white background. Aligned in a row, the buildings, flags, crown, and chain-link fence suggest a kind of narrative, like a storyboard. Yet, oddly enough, piecing together the fragments of the story requires no intellectual effort; rather, the impact of the work is received spontaneously as a general impression of the relationship between the disparate symbols. At times Twaddle also represents symbols in isolation, as in *Crop* and *Religion.* In such cases, the viewer is alone with the image and the associations it arouses without the distraction of narrative to relieve the tension of the confrontation.

Selected Group Exhibitions

1984
Art Museum of South Texas, Corpus Christi, *Singular Points of View.* Catalogue, with text by Jim Edwards

Student Center Gallery, Texas Christian University, Fort Worth, *New Talent in Texas.* Catalogue, with text by Susan Freudenheim

Grand Army Plaza and Bowling Green Park, New York, *Sign on a Truck*

1985
Los Angeles Institute of Contemporary Art

Selected Bibliography

1983
Janet Kutner. ''Warehouse of Dreams.'' *Dallas Morning News,* September 16, 1983, p. C1.

1984
Vernon Fisher. ''Exhibit at TCU Spotlights Unseen Artists.'' *Fort Worth Star Telegram,* January 29, 1984, p. D1.

1985
David Regan and Kevin Noble. ''Public Address: 'Sign on a Truck.''' *Art in America,* vol. 73, no. 1 (January 1985), pp. 88–91.

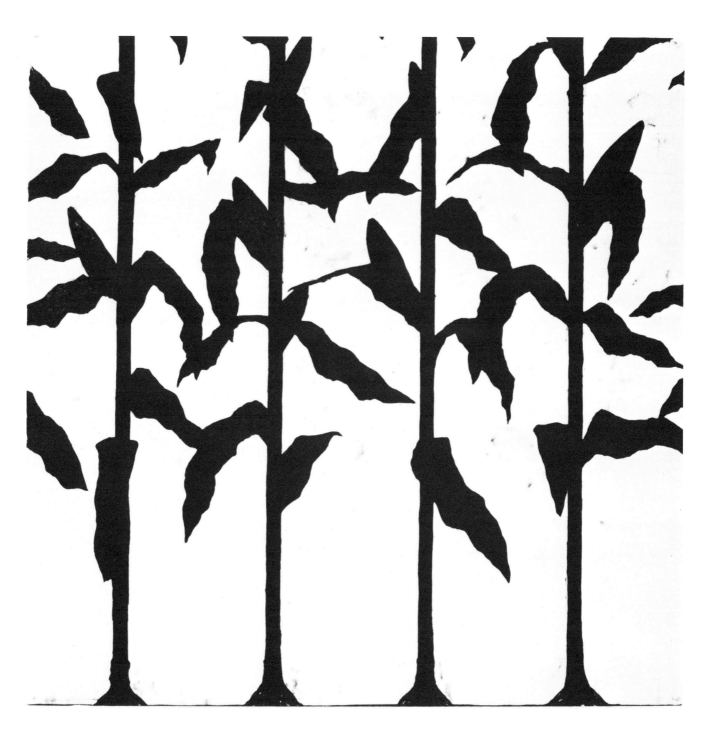

RANDY TWADDLE
Crop, 1985
Charcoal on paper, 44 x 44 inches
Moody Gallery, Houston

ROBIN WINTERS

Born 1950 in Benicia, California

Studied 1971 at San Francisco Art Institute

Participated 1972 in Independent Study Program, Whitney Museum of American Art, New York

Resides in New York and Amsterdam

Robin Winters is an extraordinarily versatile artist—a draftsman, performance artist, painter, writer, sculptor, and artisan. His art is full of references to such personal experiences as his childhood in California, his studies at the San Francisco Art Institute, his work in factories, and his move to New York City in 1972. Although any attempt to separate media in his work would constitute a violation of his own striving for a true *Gesamtkunstwerk,* it is fair to say that drawing constitutes a large portion of his oeuvre and that a linear quality is present in all his work. Even his paintings are drawn in paint.

A true humanist, Winters believes that art still has the magical power to open people's hearts and eyes. Although he is most in contact with his public during his performances, he also involves the spectator, as a fellow performer, in his works in other media. In *Eyes Have It* there are forty-eight faces of people he has met, talked to, or just seen. Forty-eight pairs of eyes question, contemplate, or otherwise react to the human condition. They are individuals in a crowd, rendered by the hand of an expert draftsman who has retained a childlike ability to see under the surface in his search for fables.

Selected Individual Exhibitions

1976
Artists Space, New York

1977
HALLWALLS, Buffalo

De Appel, Amsterdam

1980
Site Gallery, San Francisco

1981
Mary Boone Gallery, New York

1982
American Graffiti, Amsterdam

1983
Richard Kuhlenschmidt Gallery, Los Angeles

1984
Art Palace, New York

The New Museum of Contemporary Art, New York

1985
Jeffrey Hoffeld & Co., New York

1986
Institute of Contemporary Art, Boston. Catalogue, with text by Susan Davis, Roberta Smith, and Robin Winters

Selected Group Exhibitions

1975
Whitney Museum of American Art, New York, *1975 Biennial Exhibition.* Catalogue

1976
Akademie der Künste, Berlin, *Soho in Berlin.* Catalogue

1979
U.S. Customs House, New York. *Customs and Culture*

1980
Times Square, New York, *The Times Square Show*

1982
Alternative Museum, New York, *Face to Face*

Institute of Contemporary Art, University of Pennsylvania, Philadelphia, *Image Scavengers: Painting.* Catalogue, with text by Janet Kardon

1983
The Kitchen, New York, *Island of Negative Utopia*

1984
White Columns, New York, *Too Young for Viet Nam*

Rijksmuseum Kröller-Müller, Otterlo, Netherlands, *Little Arena: Drawings and Sculptures from the Collection of Adri, Martin and Geertjan Visser.* Catalogue

1985
Modernism Gallery, San Francisco, *New Art: 40 New York Artists*

The Museum of Modern Art, New York, *Large Drawings*

1986
Museum van Hedendaagse Kunst, Ghent, Belgium, *Chambre d'Amis (In Ghent there is always a free room for Albrecht Dürer)*

Selected Bibliography

1975
Alan Moore. [R. Winters, 597 Broadway, reviewed.] *Artforum,* vol. 13, no. 10 (Summer 1975), p. 72.

1977
RoseLee Goldberg. "New York." *Studio International* (London), vol. 193, no. 985 (January/February 1977), pp. 31–32.

1979
RoseLee Goldberg. *Performance: Live Art, 1909 to the Present.* New York: Harry N. Abrams.

1980
Jeffrey Deitch. "Report from Times Square." *Art in America,* vol. 68, no. 7 (September 1980), pp. 58–63.

Anne Ominous, AKA Lucy Lippard. "Sex and Death and Shock and Schlock: A Long Review of the Times Square Show." *Artforum,* vol. 19, no. 2 (October 1980), pp. 50–55.

1981
Thomas Lawson. [R. Winters, Mary Boone Gallery, reviewed.] *Artforum,* vol. 19, no. 9 (May 1981), p. 72.

1983
Hunter Drohojowska. "Robin Winters—Richard Kuhlenschmidt Gallery." *Flash Art* (Milan), no. 111 (March 1983), pp. 63–64.

Betsy Sussler. "I'm Not Waiting for My Ship to Come In, I'm Out Sailing." Interview. *Bomb Magazine,* no. 7 (October 1983), pp. 38–41.

1985
Sarah Cecil. "Robin Winters: Mo David." *Art News,* vol. 84, no. 3 (March 1985), p. 156.

1986
Holland Cotter. "Robin Winters at Jeffrey Hoffeld." *Art in America,* vol. 74, no. 1 (January 1986), pp. 139–40.

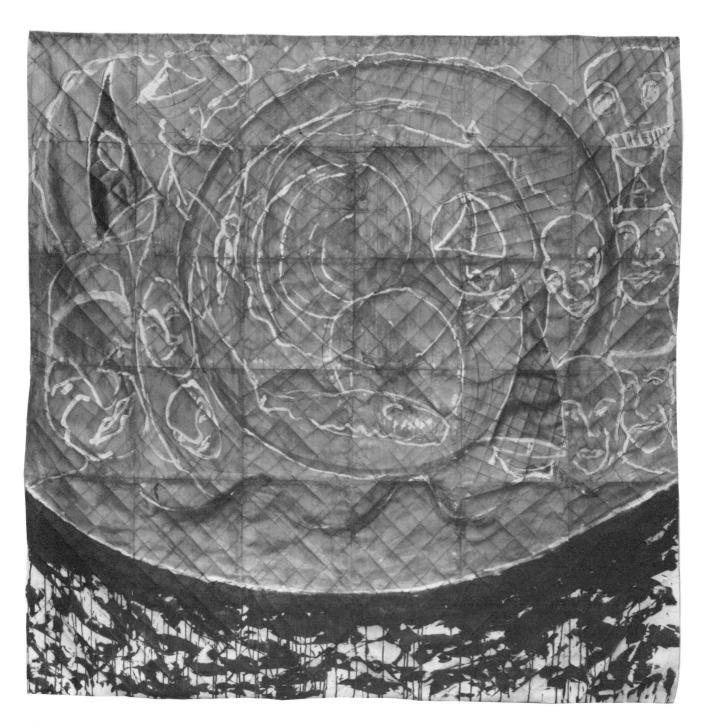

ROBIN WINTERS
Water Babies, 1986
Graphite, acrylic, and coffee on folded paper,
 72 x 72 inches
Collection of the artist, courtesy of Michael Klein
 Inc., New York

TERRY WINTERS

Born 1949 in New York

B.F.A. 1971, Pratt Institute, Brooklyn

Resides in New York

Terry Winters investigates a fragmented diluvial world of mysterious plantlike organisms, creating a vocabulary of shapes and forms very much his own. His drawings are not abstract: we can, or so it seems, recognize floral or cellular shapes reminiscent of those illustrated in science magazines. At closer scrutiny, however, we are confronted by the enigmatic creation of an alchemist and forced to think beyond the visible. Sensuous surfaces underscore the mystery of this imaginary universe. Winters' work is about figure-ground relationships, spatial configurations, gesture, and color. It is complex and highly cerebral, often concentrating on solving purely formal problems.

Selected Individual Exhibitions

1982
Sonnabend Gallery, New York

1983
Reed College, Portland, Oregon

1984
Sonnabend Gallery, New York

Daniel Weinberg Gallery, Los Angeles

1985
Kunstmuseum Luzern, Lucerne, Switzerland. Catalogue, with text by Klaus Kertess and Martin Kunz

1986
Castelli Graphics, New York

Sonnabend Gallery, New York

Selected Group Exhibitions

1977
The Drawing Center, New York, *Summer/77*

P.S. 1, The Institute for Art and Urban Resources, Long Island City, New York, *A Painting Show*

1980
Leo Castelli Gallery, New York, *Drawings: For the Benefit of the Foundation for Contemporary Performances, Inc.*

1981
Delahunty Gallery, Dallas, *Committed to Paint.* Catalogue, with text by Klaus Kertess

1982
The Parrish Art Museum, Southampton, New York, *How to Draw/What to Draw: Works on Paper by Five Contemporary Artists*

1983
Tate Gallery, London, *New Art at the Tate Gallery 1983.* Catalogue, with text by Michael Compton

1984
The Museum of Modern Art, New York, *An International Survey of Recent Painting and Sculpture.* Catalogue

Hillwood Art Gallery, C.W. Post Center, Long Island University, Greenvale, New York, *Reflections: New Conceptions of Nature.* Catalogue, with text by Judith Van Wagner

1985
Whitney Museum of American Art, New York, *1985 Biennial Exhibition.* Catalogue

1986
Jeffrey Hoffeld & Co., New York, *Drawings: Carroll Dunham, John Newman & Terry Winters*

Selected Bibliography

1982
Grace Glueck. ''The Artists' Artists.'' *Art News,* vol. 81, no. 9 (November 1982), pp. 94–95.

1983
Therese Lichtenstein. ''Terry Winters.'' *Arts Magazine,* vol. 57, no. 6 (February 1983), p. 33.

1984
Prudence Carlson. ''Terry Winters' Earthly Anecdotes.'' *Artforum,* vol. 23, no. 3 (November 1984), pp. 65–68.

1985
Ramon Tio Bellido. ''Whitney: une biennale contestée.'' *L'Art vivant* (Paris), no. 12 (Summer 1985), p. 26.

1986
Robert Hughes. ''Obliquely Addressing Nature: In New York, Terry Winters' Stimulating One-Man Show.'' *Time,* February 24, 1986, p. 83.

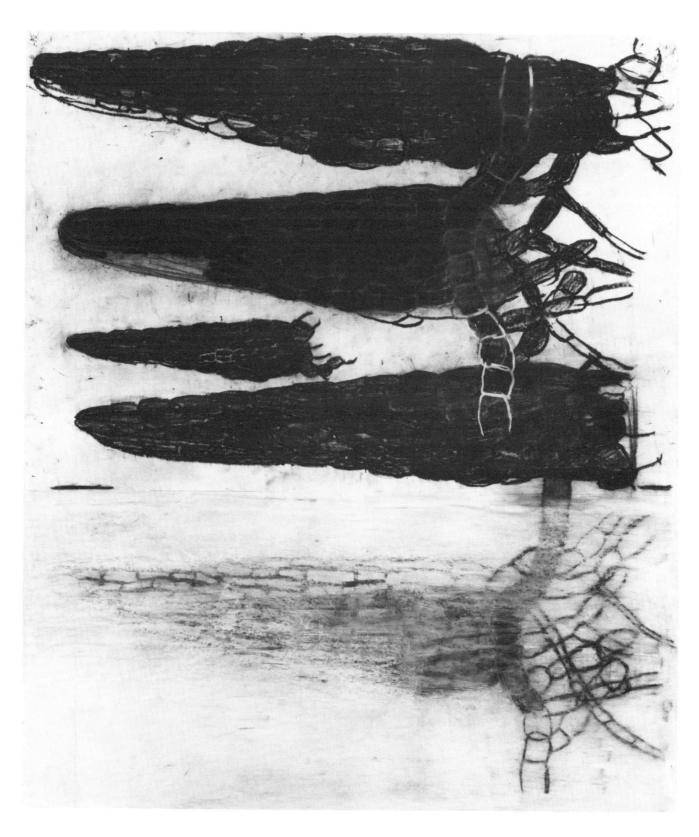

TERRY WINTERS
Untitled, 1983
Charcoal, chalk, and crayon on paper, 63 x 60 inches
Collection of Estelle Schwartz

MICHAEL ZWACK

Born 1949 in Buffalo

B.A. 1970, State University of New York College at Buffalo

Resides in New York

Michael Zwack draws his inspiration from photojournalism and illustrated books, taking images from these sources and subjecting them to profound transformations. He works slowly and with great concentration, displaying empathy not only for his subjects but also for the whole of humanity. While the large expressive faces he draws are always those of particular individuals, the feelings of pain, grief, anger, or surprise they express are universal. This discovery of the universal in the particular also applies to the rendering of nature in his *History of the World* series. Here he transforms an image of an existing landscape into a segment of the whole universe. The materials he uses, powdered pigments and linseed oil, are instrumental in creating the blurred outlines that bring a mysterious, slightly nostalgic, timeless element to his work.

Selected Individual Exhibitions

1975
HALLWALLS, Buffalo

1979
Artists Space, New York

1980
Studio d'Arte Cannaviello, Milan

1981
Metro Pictures, New York

1983
Metro Pictures, New York

1984
Texas Gallery, New York

1985
Grace Borgenicht Gallery, New York. Catalogue, with text by Douglas Blau

1986
Weatherspoon Art Gallery, University of North Carolina, Greensboro

Michael Kohn Gallery, Los Angeles

Selected Group Exhibitions

1977
Artists Space, New York, *Silent Auction*

1979
Upton Gallery, State University of New York College at Buffalo, *HALLWALLS, Buffalo: Five Years*. Traveled. Catalogue, with text by Linda L. Cathcart

1980
Brooke Alexander Gallery, New York, *Illustration and Allegory*. Catalogue, with text by Carter Ratcliff

1982
P.S. 1, The Institute for Art and Urban Resources, Long Island City, New York, *Six Critical Perspectives*

Hayden Gallery, Massachusetts Institute of Technology, Cambridge, *Great Big Drawings: Contemporary Works on Paper*. Catalogue, with text by Katy Kline

1983
Weatherspoon Art Gallery, University of North Carolina, Greensboro, *Art on Paper*

1984
Contemporary Arts Museum, Houston, *The Heroic Figure*. Traveled. Catalogue, with text by Linda L. Cathcart and Craig Owens

1985
Procter Art Center, Bard College, Annandale-on-Hudson, New York, *Sculpture*

1986
Diane Brown Gallery, New York, *Time after Time (A Sculpture Show)*

Curt Marcus Gallery, New York, *Inaugural Exhibition*

Selected Bibliography

1976
Nancy Tobin Willig. "Buffalo: Typestyles and Photographic Manipulations." *Art News*, vol. 75, no. 8 (October 1976), pp. 106–8.

1980
Deborah C. Phillips. "Illustration and Allegory: Brooke Alexander." *Arts Magazine*, vol. 55, no. 1 (September 1980), pp. 25–26.

Joan Simon. "Double Takes." *Art in America*, vol. 68, no. 8 (October 1980), pp. 113–17.

1981
Valentin Tatransky. "Fischl, Lawson, Robinson and Zwack: They Make Pictures." *Arts Magazine*, vol. 55, no. 10 (June 1981), pp. 147–49.

1982
Donald Kuspit. "'Critical Perspectives,' P.S. 1." *Artforum*, vol. 20, no. 8 (April 1982), pp. 81–83.

RoseLee Goldberg. "Post-TV Art." *Portfolio Magazine*, vol. 4, no. 4 (July–August 1982), pp. 76–79.

1983
Richard Armstrong. "Other Views: Semaphore Gallery," *Artforum*, vol. 22, no. 4 (December 1983), pp. 83–84.

1985
Keith Dills. "Contemporary Figures and Questions." *Artweek* (Oakland, California), vol. 16, no. 20 (May 18, 1985), p. 1.

Holland Cotter. "Michael Zwack at Borgenicht." *Art in America*, vol. 73, no. 11 (November 1985), pp. 165–66.

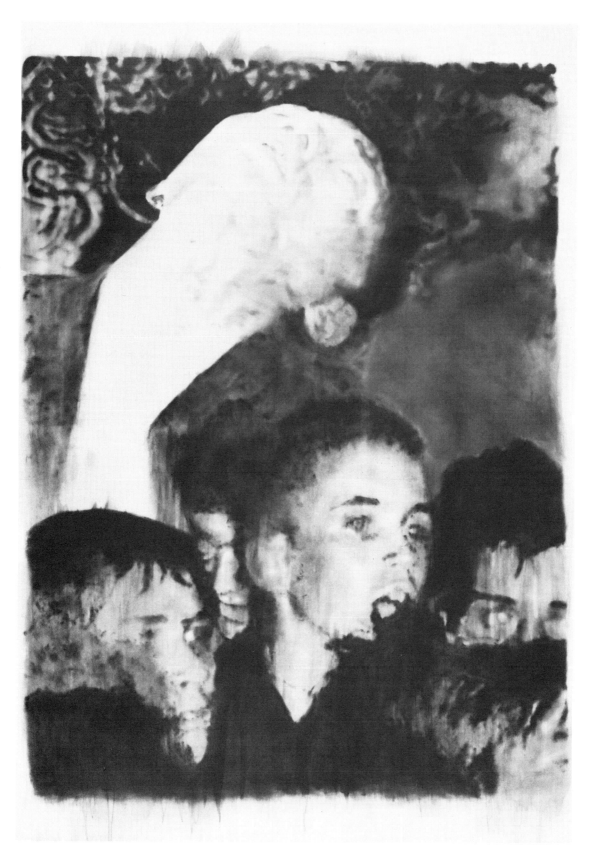

MICHAEL ZWACK
Untitled, 1982
Raw pigment and oil on paper, 79 x 54 inches
Collection of Dr. Shelley Kolton and Maureen Klette,
 courtesy of Curt Marcus Gallery, New York

CHECKLIST

Dimensions are in inches; height precedes width.

ZIGI BEN-HAIM

Floating Scape #1, 1985
Oil pastel, synthetic charcoal, and pigments on primed paper and burlap,
 88 x 119
Collection of the artist
(Illustrated)

Floating Scape #III, 1985
Oil pastel, synthetic charcoal, and pigments on primed paper and burlap,
 88 x 119
Collection of the artist

CYNTHIA CARLSON

Blocher, 1985
Charcoal, pastel, and copper leaf on paper with collage, 2 sections, 138 x 132
 overall
Collection of the artist
(Illustrated)

Rich, 1985
Charcoal and pastel on paper with collage, 120 x 114
Collection of the artist

Rogers, 1985
Charcoal, pastel, and silver leaf on paper with collage, 132 x 84
Collection of the artist

Buffalo Couch, 1986
Charcoal and pastel on paper, 96 x 84
Collection of the artist

ROBERT CUMMING

Neumetric Kraft Alphabet, 1984
Acrylic, charcoal, ink, and pencil on paper, with handwoven paper, 60 x 77
Collection of J. Walter Thompson Company, New York

Soap, Plan, Bars, Four, Sign, 1984
Acrylic, charcoal, ink, and pencil on paper, 60 x 77
Collection of Generale Bank, New York

Special Entry, 1986
Acrylic on paper, 60 x 77
Castelli Uptown, New York
(Illustrated)

CARROLL DUNHAM

M from the series *Seventeen Drawings*, 1985
Mixed media on maple veneer, 36 x 24
Collection of Raymond Learsy

P from the series *Seventeen Drawings,* 1985
Mixed media on maple veneer, 48 x 35⅞
Private collection, courtesy of Baskerville + Watson, New York

Untitled 5/6/85, 1985
Casein, flashe, casein emulsion, carbon pencil, charcoal, ink, and linen on
 zebrano and knotty pine, 42¾ x 31¼
The Museum of Modern Art, New York; The Louis and Bessie Adler Fund
(Illustrated)

JOYCE FILLIP

Waterspouts, from the series *Natural Disasters,* 1983
Charcoal and pastel on paper, 96 x 108
Struve Gallery, Chicago
(Illustrated)

Thirty-foot Swell, from the series *Natural Disasters,* 1983
Charcoal and gesso on paper, 96 x 108
Marian Locks Gallery, Philadelphia

Texas Tornado, from the series *Natural Disasters,* 1984
Charcoal and pastel on paper, 114 x 60
Struve Gallery, Chicago

JOHN HIMMELFARB

Dream Meeting, 1986
Ink on paper, 40 x 60
Brody's Gallery, Washington, D.C.

Giants Meeting, 1986
Ink on paper, 96 x 144
Terry Dintenfass, New York
(Illustrated)

BRYAN HUNT

Untitled, 1981
Graphite and linseed oil on paper, 83 x 41½
Blum Helman Gallery, New York

Door Series, 1982
Graphite, conté crayon, and linseed oil on paper, 84½ x 34
Collection of Mr. and Mrs. Warren Adelson

Working Drawing for Barcelona Project—Rite of Spring—Left, 1986
Graphite and oil stick on paper, 168 x 60
Collection of the artist
(Illustrated)

Working Drawing for Barcelona Project—Rite of Spring—Right, 1986
Graphite and oil stick on paper, 168 x 60
Collection of the artist
(Illustrated)

ROBERT LONGO

Men in the Cities, 1981–86
Charcoal and graphite on paper, 96 x 60
Collection of Richard Price
(Illustrated)

Men in the Cities, 1981–86
Charcoal and graphite on paper, 96 x 60
Collection of the artist

ROBERT MOSKOWITZ

Thinker, 1982
Pastel on paper, 53 x 31¼
Collection of the artist
(Cover illustration)

Giacometti Piece (for Bob Holman), 1984
Pastel on paper, 108 x 41⁹⁄₁₆
Collection of the artist
(Illustrated)

Red Cross, 1985
Pastel on paper, 37⅞ x 38
Collection of Dr. and Mrs. Sheldon Krasnow

BRUCE NAUMAN

Life, Death, Love, Hate, Pleasure, Pain, 1983
Watercolor, pastel, pencil, and charcoal on paper, 80 x 80
Leo Castelli Gallery, New York
(Illustrated)

Crossed Stadiums, 1984
Synthetic polymer paint, charcoal, watercolor, and pastel on paper, 53 x 72½
The Museum of Modern Art, New York; Gift of The Lauder Foundation

Big Welcome, 1985
Gesso, watercolor, and pencil on paper, 37 x 119½
Leo Castelli Gallery, New York

JOHN NEWMAN

Nomen Est Numen, 1984
Chalk and graphite on paper, 106 x 46
Collection of Martin Sklar

Sidesplitter, 1985
Chalk, oil stick, and pencil on paper, 89 x 65
Collection of Bette and Herman Ziegler

Untitled (Nested Tori), 1985
Chalk, oil stick, and graphite on paper, 92 x 60
Collection of Edward R. Downe, Jr.
(Illustrated)

DIANE OLIVIER

Fourth Street II, 1984
Charcoal on paper, 80 x 109
Dorothy Weiss Gallery, San Francisco

Open Room, 1985
Charcoal on paper, 80 x 62
Collection of Jolene and Andrew Andoniadis, courtesy of Dorothy Weiss Gallery,
 San Francisco
(Illustrated)

ELFI SCHUSELKA

Climbing Parnassus #26, 1985–86
Graphite on paper, 58 x 60
Collection of the artist
(Illustrated)

Climbing Parnassus #27, 1985–86
Graphite on paper, 58 x 60
Collection of the artist

Samen und Keime #4 (Seeds and Pods), 1985–86
Graphite, acrylic, and crayon on paper, 58 x 60
Collection of the artist

Samen und Keime #5 (Seeds and Pods), 1985–86
Graphite, acrylic, and crayon on paper, 58 x 60
Collection of the artist

RICHARD SERRA

Drawing for Right Hand Corner, 1984
Paint stick on paper, 84¾ x 56½ (framed)
Leo Castelli Gallery, New York

Slat, 1986
Paint stick on paper, 87⅛ x 79⅞
Collection of REFCO Group Ltd., Chicago
(Illustrated)

ROBERT STACKHOUSE

From the Deep, 1982
Watercolor on paper, 84 x 120
Collection of the artist

Deep Swimmers and Mountain Climbers, 1985
Pencil, charcoal, and watercolor on paper, 90 x 120
Collection of the artist
(Illustrated)

On the Beach Again in Its Cradle/Cheops' Ship in Its Burial Pit, 1986
Watercolor and charcoal on paper, 29½ x 82
Collection of the artist

DONALD SULTAN

Black Tulip Sept 1 1983, 1983
Charcoal on paper, 50 x 38
Private collection
(Illustrated)

Black Tulip Sept 14 1983, 1983
Charcoal on paper, 50 x 38
Collection of Joseph Helman

Black Lemons July 27 1985, 1985
Charcoal on paper, 50 x 38
Collection of The First Banks, Minneapolis

Black Egg Black Lemon Feb 16 1986, 1986
Charcoal on paper, 60 x 48
Collection of the artist, courtesy of Blum Helman Gallery, New York

ANDREW TOPOLSKI

A Sound Measure/de-Tonation I–IV, 1986
Carbon, pigment, transfertype, and graphite on paper, 4 pieces, 94½ x 63½
 each
Collection of the artist
(One piece illustrated)

MICHAEL TRACY

Drawings I–IV (To R.S.B.), 1984
Ink and acrylic on paper, 4 panels, 47 x 45 each
Hiram Butler Gallery, Houston, and Hadler/Rodriguez Gallery, Houston

From the series *Destino Abierto I–IV, VI, IX,* 1985–86
Watercolor, Cray-Pas, acrylic, oil stick, and gouache on paper, 6 panels, 45 x 61
 each
Hiram Butler Gallery, Houston, and Hadler/Rodriguez Gallery, Houston
(Panel III illustrated)

RANDY L. TWADDLE

Corporate Imperialism, 1984
Charcoal on paper, 42½ x 81
Collection of the artist

Crop, 1985
Charcoal on paper, 44 x 44
Moody Gallery, Houston
(Illustrated)

Religion, 1985
Charcoal on paper, 44 x 44
Collection of Christian Frederiksen

ROBIN WINTERS

Eyes Have It, 1981
Watercolor on paper, 74 x 89
Private collection

Untitled, 1986
Mixed media on paper, 95¼ x 71¼
Collection of the artist, courtesy of Michael Klein Inc., New York
Water Babies, 1986
Graphite, acrylic, and coffee on folded paper, 72 x 72
Collection of the artist, courtesy of Michael Klein Inc., New York
(Illustrated)

TERRY WINTERS

Dark Plant No. I, 1982
Charcoal, chalk, and crayon on paper, 42 x 29½
Collection of Susan Lorence

Dark Plant No. II, 1982
Charcoal, chalk, and crayon on paper, 41½ x 29½
Collection of the artist
Untitled, 1983
Charcoal, chalk, and crayon on paper, 63 x 60
Collection of Estelle Schwartz
(Illustrated)

Ring I, 1984
Charcoal, pastel, and crayon on paper, 42 x 29¾
Collection of Ileana and Michael Sonnabend

Ring II, 1984
Charcoal, pastel, and crayon on paper, 42 x 29¾
Collection of the artist

Untitled, 1986
Graphite on paper, 48 x 32
Collection of the artist, courtesy of Sonnabend Gallery, New York

MICHAEL ZWACK

Untitled, 1982
Raw pigment and oil on paper, 79 x 54
Collection of Dr. Shelley Kolton and Maureen Klette, courtesy of Curt Marcus
 Gallery, New York
(Illustrated)

History of the World, 1984
Raw pigment and oil on paper, 60 x 97
Curt Marcus Gallery, New York

History of the World, 1984
Raw pigment and oil on paper, 43 x 91
Collection of Aron and Phyllis Katz

LENDERS
TO THE EXHIBITION

Mr. and Mrs. Warren Adelson
Jolene and Andrew Andoniadis
Zigi Ben-Haim
Cynthia Carlson
Edward R. Downe, Jr.
Christian Frederiksen
Joseph Helman
Bryan Hunt
Aron and Phyllis Katz
Dr. Shelley Kolton
 and Maureen Klette
Dr. and Mrs. Sheldon Krasnow
Raymond Learsy
Susan Lorence
Robert Longo
Robert Moskowitz
Richard Price
Elfi Schuselka
Estelle Schwartz
Martin Sklar
Ileana and Michael Sonnabend
Robert Stackhouse
Donald Sultan
Andrew Topolski
Randy L. Twaddle
Robin Winters
Terry Winters
Bette and Herman Ziegler
Private collections

The First Banks, Minneapolis
Generale Bank, New York
REFCO Group Ltd., Chicago
J. Walter Thompson Company,
 New York

The Museum of Modern Art,
 New York

Baskerville + Watson, New York
Blum Helman Gallery, New York
Brody's Gallery,
 Washington, D.C.
Hiram Butler Gallery, Houston
Leo Castelli Gallery, New York
Castelli Uptown, New York
Terry Dintenfass, New York
Hadler/Rodriguez Gallery,
 Houston
Michael Klein Inc., New York
Marian Locks Gallery,
 Philadelphia
Curt Marcus Gallery, New York
Moody Gallery, Houston
Sonnabend Gallery, New York
Struve Gallery, Chicago
Dorothy Weiss Gallery,
 San Francisco